THE COLLECTOR'S ROOM

Selections from the

Michael and Judy Steinhardt Collection

CISSY GROSSMAN

The Joseph Gallery

in cooperation with the

Hebrew Union College Skirball Museum, Los Angeles

HEBREW UNION COLLEGE – JEWISH INSTITUTE OF RELIGION

BROOKDALE CENTER ONE WEST FOURTH STREET NEW YORK NY 10012

THE COLLECTOR'S ROOM
Selections from the Michael and Judy Steinhardt Collection

Cissy Grossman, curator
Reva Godlove Kirschberg, research coordinator
Aviva Jacobs Hoch, researcher
Laura Kruger, Joseph Gallery coordinator
Lucian J. Leone and David Kleinard, Leone Design Group,
 exhibition designers
Jean Bloch Rosensaft, catalog editor
Patrick Vitacco, By Design, catalog designer
Janice Loeb, objects installer
R.H. Guest, Inc., exhibition fabricators
Michael Prudhom, lighting designer
Cora Ginsburg, lender, furniture and Italian silk panel

This exhibition and catalog have been made possible
by a generous grant from the Michael and Judy Steinhardt
Foundation.

Published in the United States of America in 1993 by
Hebrew Union College–Jewish Institute of Religion
Brookdale Center, One West 4th Street,
New York, NY 10012-1186

LIBRARY OF CONGRESS CATALOGING-IN-PUBLICATION DATA
Grossman, Cissy.
 The Collector's Room: Selections from the Michael and
Judy Steinhardt Collection / Cissy Grossman
 p. cm.
 Exhibition catalog.
 Includes bibliographical references.
 $12.00
 1. Art, Jewish--Exhibitions. 2. Jewish art and symbolism--
Exhibitions. 3. Steinhardt, Michael--Art collections--Exhibitions.
4. Steinhardt, Judy--Art collections--Exhibitions. 5.--Art--Private
collections--New York--New York--Exhibitions. I. Hebrew Union
College Skirball Museum. II. Title
 N7414.9.S74G76 1993
 704'.03924'00747471--dc20 93-29222
 ISBN 1-884300-00-6 CIP

Cover illustration:

Venezia Torah Crown and Bells (cat. no. 11)
from the Michael and Judy Steinhardt Collection

17th-century Italian silk panel with gilt braid edge,
on loan from Cora Ginsburg

FOREWORD

Michael and Judy Steinhardt's extraordinary Judaica collection celebrates the beauty of Jewish tradition, ritual observance and artistic expression. The Steinhardts' devotion to their Jewish heritage together with their outstanding aesthetic sensibility have impelled them to care for these precious works which reflect Jewish life through the centuries, in Israel and throughout the Diaspora. Their commitment to Jewish knowledge enables scholars to study these rare works of art and to augment the ever-growing realm of Judaic scholarship. We are most grateful for their friendship to Hebrew Union College–Jewish Institute of Religion and thank them for choosing us to help share the treasures of their Judaica collection. Their generosity and vision encourages our efforts to carry out our historic mission.

The College–Institute's abiding purpose is the education of the future leaders of world Jewry—the rabbis, cantors, educators, communal workers and scholars who will perpetuate our glorious Jewish heritage for the generations to come. Intrinsic to this mission and central to our educational programs are the vast research resources of Jewish material culture which are preserved and disseminated on our campuses through our libraries, archives and museums.

From the very inception of the College–Institute in 1875, Rabbi Isaac Mayer Wise recognized the unique importance of preserving works of Judaic art. He understood that these objects were an expression of faith, a testament to Jewish life and a reminder of our singular role and responsibility as Jews. Today, our Skirball Museums in Los Angeles, Cincinnati and Jerusalem and our Joseph Gallery in New York are recognized for their leadership in presenting the continuum of Jewish experience from Biblical antiquity through contemporary Jewish identity. Our Skirball Cultural Center, currently under construction in Los Angeles, will greatly expand the College-Institute's educational and cultural outreach.

Our gratitude goes to Cissy Grossman for her exemplary scholarship and expertise as curator of this exhibition and for preparing this catalog. She has been the curator of several exhibitions at the College-Institute, including *Hana Geber: Sculptures of Religious Passion* at the Joseph Gallery, *Fragments of Greatness Rediscovered: A Loan Exhibition from Poland* at the Skirball Museum, Los Angeles, and an exhibit on the history of the College-Institute permanently on view at the New York School.

The Collector's Room: Selections from the Michael and Judy Steinhardt Collection celebrates the Jewish past and symbolizes the enduring meaning of our people's survival and renewal. It inspires our commitment to perpetuate our Jewish spiritual, intellectual and cultural heritage for the generations to come.

Dr. Alfred Gottschalk
President

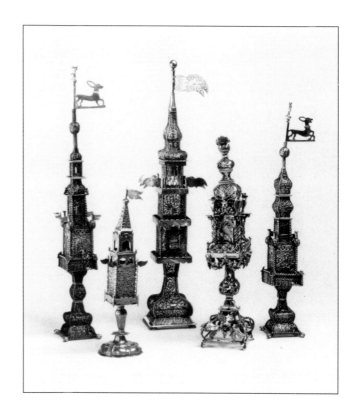

Figure 1. Five Tower-form Spice Containers (cat. nos. 1–5)

PREFACE

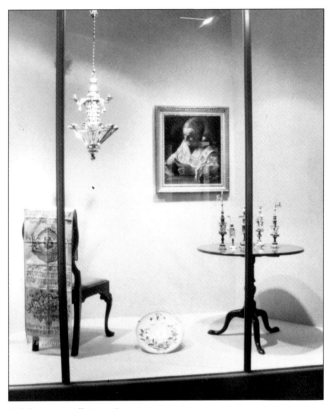

Exhibition installation: Group one

Judaic objects do not have a life of their own. They are created in a specific time and place by artists and craftspeople, either for personal use or for sale, and often they are especially commissioned. They are made in the materials available, and in a style that is meaningful to the maker and the patron. Sometimes they remain within families, carrying their history with them, and other times they change ownership. When they are separated from their past owners, we may no longer know who made them or whose possessions they were.

New owners cherish these objects for entirely different reasons, perhaps for their aesthetic qualities or perhaps for the history which they are thought to represent; these new owners save them, care for them, and continue to breathe life into them. What they choose to save is critically important, because that choice inspires a re-examination and reconsideration of the significance of that work within the context of contemporary life.

Judy and Michael Steinhardt have a wide range of interest in art and artifacts. They are collectors of 20th century works on paper, Chinese and Peruvian textiles, and Classical and Near Eastern antiquities. In addition, they have collected 20th century Israeli art and archaeological artifacts from the Land of Israel. That they have elected to extend that interest to objects of Judaica is immensely important to the study of Jewish art and Jewish history. The objects of the Jewish people have status in their eyes. In this exhibition, we have looked at objects of ritual observance and daily life with a fresh viewpoint.

How does the curator choose from a large and important collection? What has value for the scholar as well as for the lay person? Among the treasures of this collection, you will discover valuable silver and gold objects, commissioned by wealthy European Jews from important non-Jewish workshops in big cities, as well as works made by local Jewish artists in small towns.

Alienated from major European trends in art, Polish and Russian Jews were inspired in their piety by Talmudic tales and Bible stories which they then transformed into designs for adornments for the sacred Torah scrolls in their synagogues. One sees creativity on the part of East European silversmiths expressed in fanciful containers that hold spices used at the conclusion of the Sabbath when Havdalah blessings are recited: tiny boxes shaped like birds, animals, or fruit.

The simplicity and variety of the charity boxes (Figure 2), which Michael and Judy Steinhardt have long collected, starkly represent the strong sense of communal responsibility that has always existed in large and small Jewish communities throughout the world.

In this exhibition, we have presented a selection of objects and Jewish works of art as a personal view. Rather than exhibiting them within the context of liturgy, ritual or observance, as Judaica is usually presented, these objects are now viewed as objects of aesthetic and cultural choice as they were once seen in a *Kunstkammer*, an art treasure room formerly found in palaces and homes of European aristocracy.

Thanks must be expressed to the many scholars and friends who have generously shared their expertise on many objects in this collection: to Shalom Sabar of the Hebrew University in Jerusalem for his insights on the Italian ketubbot; to Rochelle Weinstein of the City University of New York for her information on the megillah and the Dutch ketubbah; to Daniel M. Friedenberg for his scholarship on the menorah stamp seal; to Leonard Gorelick for his assistance with the ancient Hebrew sailing ship seal; and to Rafi Grafman for conferring on several rare hallmarks.

Cora Ginsburg, with her unfailing generosity, lent the exhibition rare and splendid furnishings which enhanced the sense of domestic intimacy in "The Collector's Room."

Philip Miller, Librarian of the College-Institute's Klau Library, graciously translated our Hebrew inscriptions. Reva Kirschberg expertly served as registrar and as a skillful and indefatigable researcher. Aviva Hoch was an excellent research assistant. Lucian Leone, of Leone Design Group, transformed the gallery into an evocative, personalized space. Laura Kruger, Chair of the Joseph Gallery Advisory Committee, helpfully facilitated all aspects of the exhibition, ably assisted by Linda Jaffe.

Sheldan Collins beautifully photographed the objects for this catalog, which was elegantly conceived by Patrick Vitacco, of By Design, and edited and produced by Jean Bloch Rosensaft. We thank them all.

It was a great privilege to work with the Steinhardts. They generously allowed me the freedom to choose from their many great Judaica objects and extraordinary works of art. Their personal enthusiasm made the project a great pleasure.

I must gratefully acknowledge Rabbi Norman J. Cohen, Dean of the College-Institute's New York School, for his wisdom and support and for enabling this special opportunity to come to fruition.

Cissy Grossman
Curator

Figure 2. Charity Boxes (top, left to right: cat. nos. 123, 120, 121, 122, 118; center: cat. nos. 127, 129, 131; bottom, cat. nos, 119, 125, 126, 128, 130).

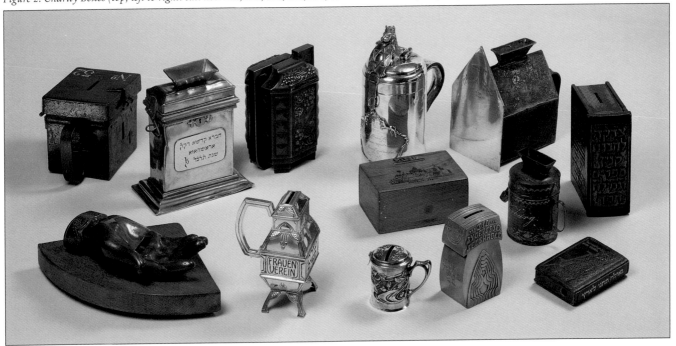

Breaking the Code: Finding Meaning in Jewish Works of Art

The decorative arts, which rightfully include Judaica objects, are generally presented in terms of "style." Style, of course, suggests "lifestyle" – how people live and their notions of time and place and self. Do objects express the ideas of their own time and place or do they harken to other times and places and notions of self? It is interesting to note that 20th century Torah ornaments are so often created in a neo-baroque or rococo style. Why does an 18th century European style seem more appropriate to synagogue committees than the style of their contemporaries? Perhaps the simplicity of the modern has no place to encode a sense of history or of religiosity. One wants curtains, lions, Tablets of the Law, and complex surface detail.

Symbols, motifs and style are replete with meaning, however subliminally they are expressed. We respond to visual signs without great awareness of these responses. Certain works of art upset us, offend us, or please us. In the

Figure 3. Pewter Passover Plate (cat. no. 86).

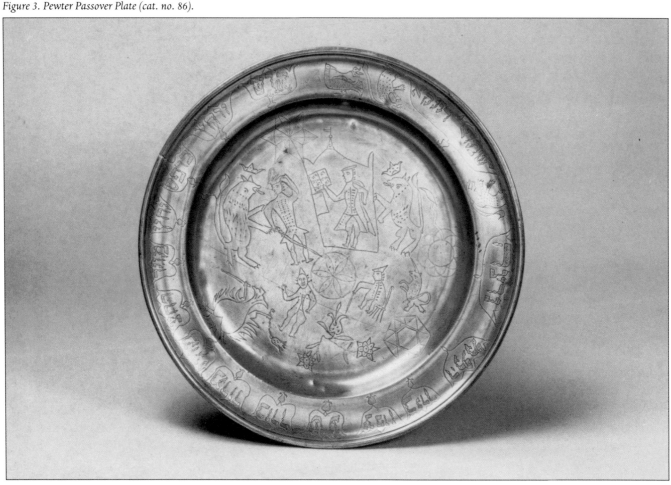

realm of objects, the meaning of signs seem totally ignored in the welter of descriptive matter. What is the material employed by the artist? What is the style? What are the techniques? Who are the makers?

The material used and the techniques employed inform us of their availability and the preferences of the artists and makers. But what do such restrictions of material and choices of technique actually signify? What did symbols and motifs mean to the makers and users of these works? What do they signal to us? What are the hidden and not-so-hidden meanings?

Jewish objects are made by Jews and non-Jews to be used in the Jewish home or synagogue. In Western Europe, before the changes enacted by Napoleonic law, the Church defined the legal systems and kept the craft guilds closed to Jews. How did the Jewish patron find expression in commissioned decorative works without being allowed to create in a hands-on fashion? How did the folk crafts, extra-legal and outside the mainstream of the prevailing culture, express the values and ideas of the Jewish artist as well as of the Jewish client?

In the Michael and Judy Steinhardt Collection, we have the unique opportunity to examine many rare objects in silver, gold, pewter, ceramic, wood, iron, glass, and clay, from Jewish communities all over the world, ranging in date from antiquity to modern times. Works on paper from Israel form a special group projecting the romanticism of "The Land" which embodied the early visions of Zionism. In this discussion, we will examine a few objects and one drawing in the collection in an effort to uncover some of the underlying meanings in these works.

The clear "folk" quality of the Steinhardt pewter Passover plate (Figure 3; cat. no. 86) has much to reveal to us. The pewter plate itself was made in a Christian pewter workshop; Jews were not allowed in the pewterers' guilds. The blank plate was purchased, new or old, in a big city, and taken to a small town where the Jewish artist was probably unfamiliar and uninterested in the mainstream decoration of plates, which in the city might be the engraving in the center or rim of elegant, symetrical, gothic letters representing the initials of the owner. Instead, the Jewish artist wished to make a "holiday" plate out of the expensive pewter blank. Using small rotary engraving tools and simple metal gouges, the artist engraved the order of the Passover ceremony into the rim. He also proudly inscribed

the names of the owners: "Shmuel and Raika". This is a plate to be used during Passover, one week of the year, and for the rest of the year to be displayed as a household decoration, clearly a sign of affluence.

In the large center space are figures and symbols representing the story of Passover. The Hebrew inscription designating the "Order of the Seder" service on the rim is copied from the Haggadah. Often, the center drawings also reflect or actually copy an illustrated Haggadah owned by the patron. In this case the freshness and unstudied character of the drawing suggests that it was original in conception.

The sides of the center space are set off by confronting guardian lions with crowns floating above them – the Lions of Judah. However, these lions support two of the Four Sons of the Haggadah recitation. On the right, the Wise Son is shown dressed in fine britches and tailcoat, reading a book with the Ten Commandments. He is set off in a sacred, ark-like space, one end seemingly held aloft by a balloon. On the left is the Wicked Son. In the tradition of Haggadah illustrations, he is depicted as a soldier or fighter with a spear. On the lower right, the Simple Son is depicted as small, physically frail, holding a cane, and seated in a chair. On the lower left, the Son "who knows not what to ask" is depicted as a dancing clown. Indeed, all four sons seem to be spinning around a central wheel representing the Passover Matzah. One senses that all of the figures, including a prancing unicorn, are inhabitants of a circus, and that the lions are performing circus lions.

The circus as a metaphor for life is known to us from 20th century art, but our 18th century pewter decorator was not unsophisticated in his own intellectual and artistic means. Using figures that are immediately read by his clients as the Four Sons of the Haggadah recitation, he nonetheless suggests the circus, probably known to him from small traveling circuses. The heart tucked into the lower left may encode the name of the patron, or is perhaps the artist's signature – Hertz.

The nervous line of the Jewish artist who decorated this pewter Passover plate relates to the drawing by Paul Klee (Figure 4; cat. no. 87), which is adjacently displayed in the exhibition. Klee also employed a nervous line and uses symbols in his drawing. A disjointed six-pointed Star of David is marked onto the face. The little eye openings and long nose are the "Maske" of the title: *Red Jew Mask*, dated

Figure 4. Paul Klee: Maske rote Jude (cat. no. 87).

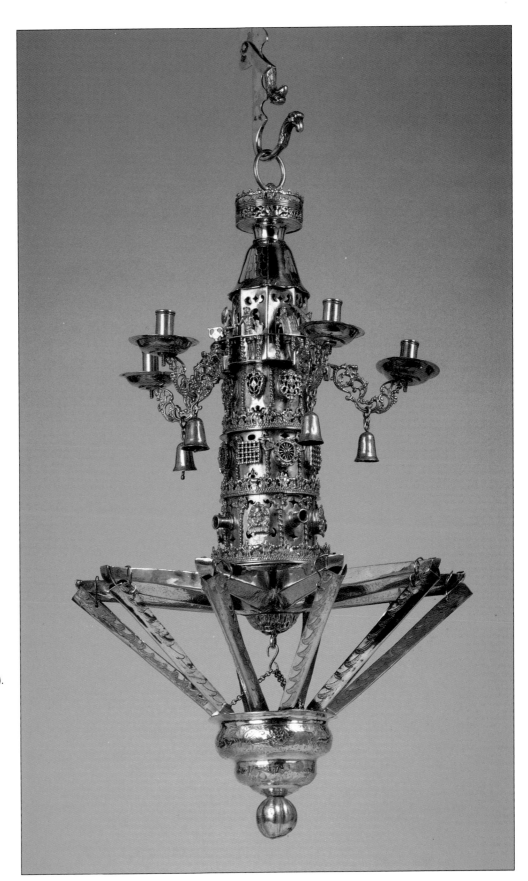

*Figure 5. Steinhardt/Boller
Hanging Sabbath Lamp (cat. no. 7).*

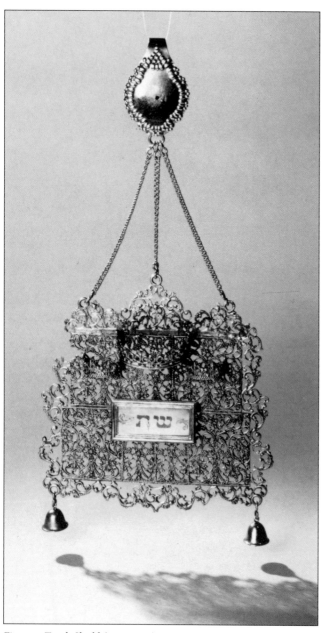

Figure 6. Torah Shield (cat. no. 71).

1933. The Jew wears the mask that conceals the real person whose rather ordinary head is shown above and to the left of the caricature mask with its long nose and beady eyes. The swastika in the lower right suggests that he is being forced to conform to the German pejorative stereotype of the Jew. The horizontal line of the swastika extends to the left and cuts across a phallic form, suggesting emasculation. Klee, who himself was not Jewish, was derided by the Nazis. His home was raided, and his work later was included in their 1937 exhibition of "degenerate" art. In 1933 he left Germany and returned to Switzerland, his birthplace.

Comparing the pewter plate made over a century earlier to the Klee drawing helps us to understand that the delicacy of both works are choices, not deficiencies of the artist. Both artists are telling us how they feel about their world. The milieu of the pewter artist is geographically small, imbued with Jewish ritual and traditional texts, and constrained by politically hostile restrictions. Klee's modern world, while unrestricted, is in this case similarly hostile. As his own life tells us, his society was hostile not only to the Jew who was branded in such a stereotypical fashion, but also to the artist whose essential requirement is always freedom of expression.

Klee's extensive work has been well documented. One hopes that a scholarly study of decorated Jewish pewter plates in museum and private collections throughout the world will reveal more of our artist (Hertz?) and his work. Such a study would also reveal more recognizable styles that were followed by many Jewish artists in the hand-decoration of holiday plates.

The Steinhardt Collection includes two unique objects from the non-Jewish silver workshops of late 17th century and early 18th century Frankfurt: The Steinhardt/Boller Sabbath Lamp (Figure 5; cat. no. 7) and the Johann Valentin Schüler Torah Shield (Figure 6; cat. no. 71).

The lamp made by Johann Adam Boller is one of several extant works which emanated from a great silversmithing workshop in Frankfurt. An object of great refinement and luxury, this lamp is large, heavy with silver, and entirely made by hand except for small decorative castings. Undoubtedly costing a goodly sum of money, the Jewish patrons apparently were able to request from the non-Jewish silversmith a lamp that was totally Jewish in form and function. Suspended over a large dining table, the

lamp was lit with candles and oil on the eve of the Sabbath and Jewish holidays, by lowering it from a ratchet-hanger. The center shaft was designed in the form of the town square fountain, well-known to the German burghers, where water would have spouted from the cannon-like projections.

According to the late Guido Schoenberger, who wrote about a similar lamp fragment in the collection of the Jewish Museum,[1] this motif was a reference to Psalm 36:10 recited on the Sabbath: "For with Thee is the fountain of life, in Thy light do we see light." The group of oil spouts around the bottom of the lamp forms a star-shape, which gave the lamp its popular designation, *Judenstern*. Eight small cast figures within an upper porch refer to various Jewish holidays, such as the man with a shofar and book signaling Rosh Hashanah and the figure with a matzah and matzah-making tool referring to Passover. This lamp clearly manifests its purpose by its fountain form and by its specific references to the holidays of the year.

From the work of Rafi Grafman,[2] a scholar who is studying Torah ornaments, we are beginning to understand the complexity of hallmarks that originate from the group of Frankfurt silversmiths that include Johann Adam Boller and Johann Valentin Schüler. Apparently there were marriages by silversmiths to widows of silversmiths, and the development of brothers and nephews as silversmiths in family-related workshops. Thus we have similar works with different hallmarks. (The Jewish Museum fragment which looks like the Boller lamp bears the hallmark of Valentin Schüler.) These silversmiths often worked in the same workshop, perhaps at different times, using the same molds, and perhaps fufilling commissions from similar clients.

The Boller lamp in the Steinhardt Collection was unknown except for a photograph of it that appeared in Schoenberger's 1951 article until it surfaced in an auction in Geneva in 1981.[3] With the exhibition and publication of this lamp, we have added another piece to the puzzle of the output of the Frankfurt workshops.

In our exhibition of several examples from the splendid collection of Torah Shields in the Steinhardt Collection, the Valentin Schüler Shield (Figure 6; cat. no. 71), also stems from the 1700s Frankfurt group and offers a glimpse into this group's special qualities.

Unlike other Torah shields, this one is not worked

Figure 7. Detail of Torah Shield (cat. no. 71).

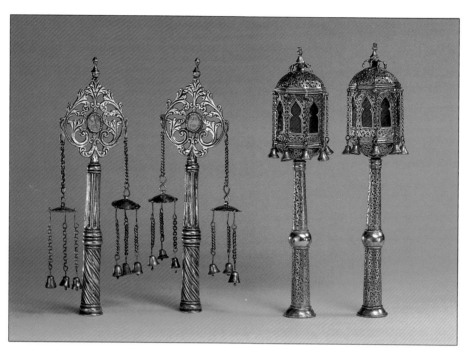

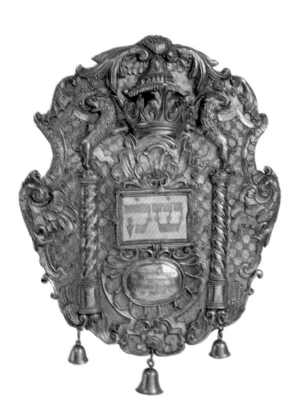

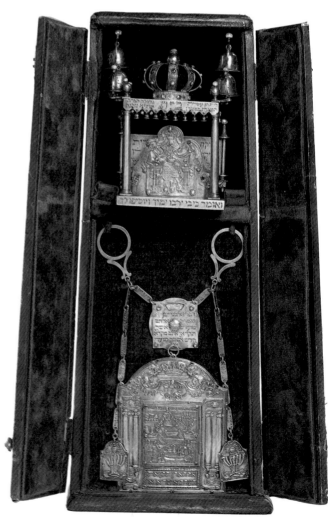

Top: Figure 8. Torah Finials (cat. nos. 93 and 92).
Above: Figure 9. Torah Shield (cat. no. 65).
Right: Figure 10. Miniature Torah Crown and Shield (cat. no. 73)

from a sheet of silver, with a cartoon or drawing as a guide to its design. The object is an assemblage. Pieces of cast silver of differing sizes were placed together in a pleasing form, outlined with cast edging, and soldered together. Three cast openwork crowns, representing "the crown of Torah, the crown of priesthood, and the crown of royalty . . ." (*Pirkei Avot 4:13*) provide its liturgical context. A small box is attached to the shield's center to provide for the interchangeable plaques which will indicate the Torah reading. The shield's bells provide musical accompaniment when it is removed from the Torah before the reading, and when it again adorns the Torah after the reading.

One is sure that this design is not pre-planned because on close observation, the pieces of silver differ. On some of the edges the work is in relief on the top surface, while another section is in relief on both sides, front and back. Therefore they were not made specifically for this shield, but were put together in a totally fresh and creative manner. Such silver sections were used in the workshop to create other objects, such as book covers or perhaps to decorate boxes or furniture. Our shield bears the clear hallmark which we duplicate here, of which Schoenberger spoke: VS within a heart, which we know to be that of Johann Valentin Schüler (Figure 7).

The edging sections have reliefs of griffons, angel heads, scrolling vegetation, flowers, fleur-de-lis; small droplets of silver add to the surface complexity. All of these elements are secular, or at least not specifically Jewish. This was acceptable to the Jewish patron for the obvious reason one sees in the photograph. The shield is breathtakingly beautiful. It looks like lace. Originally, when the silver was gilded, it looked like gold lace! The light passes through the shield, creating a shimmering openwork pattern on the fabric cover that covered the Torah scroll. An adventurous, openminded congregation must have purchased this work, for its simplicity of ornament and minimalism of symbol make it unusual for all time.

Augsburg, another great silversmithing center of the period, yielded a fine gilded silver Torah Shield in the Steinhardt Collection (Figure 9; cat. no. 65). Made in the middle of the 18th century, this shield was a product of the silversmith Hieronymus Mittnacht who is known to have made other silver ornaments for Jewish clients (see cat. nos. 57 and 58).

The Jewish symbolism it employs reveals an intimate collaboration between the artist and the Jewish patron. A magnificent work, it is more traditional than the Schüler example in that it utilizes specifically Jewish motifs although its design includes secular motifs and is au courant with elegant objects of its time.

The baroque-shaped shield is edged with high relief scrolls, leaves, and shells. Upon a diapered pattern background in relief, appliquéd rampant lions uphold a crown. They represent the lions of Judah and the crown of Torah and symbolize the Jewish people upholding the Law. The lions stand upon twisted columns which represent the façade of the Temple in Jerusalem, to remind us of the centrality of Jerusalem in the Jewish faith. In the center is a recessed box holding interchangeable plaques to designate the reading to which the particular Torah is rolled. In this case the *S[habbat] K[odesh]* (Holy Sabbath) plaque indicates the Sabbath Torah reading. Below is an elaborate cartouche on which is inscribed the dedication: "Rabbi Shmuel Katz, son of the respected Yosef Yehezkel (may the memory of the righteous be a blessing) and his wife Feigel (may she live) in the year [5]509 [1748/49]." This tender, personalized inscription tells us of the traditional reverence for parents and, with the inclusion of his wife's name, the importance of the wife to her husband.

Shmuel and Feigel Katz undoubtedly were affluent to have donated this magnificent gilded silver ornament to their synagogue, which was probably one of several that ornamented the Torah scrolls in the synagogue ark. Their ability to combine religious piety and a modern lifestyle, is eloquently represented in this shield.

The Moroccan Torah finials (Figure 8; cat. nos. 92, 93) are examples of ornaments made by Jewish artists. The silver Jewish finials are so closely tied to Islamic architectural forms that we know immediately that in these communities Jews and Muslims lived together in mutual respect. Only under such conditions would the minaret-like form and the Islamic arch be symbols of pleasure, and acceptable decorations for the Torah.

The miniature Torah crown and its shield (Figure 10; cat. no. 73) were made by a Jewish artist in Slovakia of silver and gilded silver, and ornamented with pearls and precious stones. Their velvet-lined box indicates that it was only taken out on special occasions, or possibly used by a traveler. The Torah upon which it would be placed was wrapped separately in a cloth mantle.

The design of this set is totally idiosyncratic. The artist has devised an ornament that is not based on a king's crown, but is instead a square-shaped canopy, on which sits a tiny crown. What better form for a Torah crown than a bridal canopy, since in the liturgy the Sabbath is called a bride.

A shield usually hangs from the wooden Torah staves by a chain or group of chains; in this case the artist has contrived two circlets, which allow the ornaments to hang exactly as he has designed them. Instead of one shield there are four: a main shield, a small amulet-like roundel with an opening that turns to indicate the Torah reading; and two tiny shields on long chains which carry depictions of the Temple menorah, reminders of Jerusalem. The design of the ark-shaped shield similarly represents the façade of the Temple in Jerusalem. A striking feature of this set of ornaments is the use of beautifully inscribed Hebrew texts as ornament. The texts are appropriate to the Sabbath and Festivals and were probably favorite passages of the artist taken from Scriptures and the Prayer Book.

At the bottom the artist proudly tells us his credo: "See here something new which never existed since the time the Torah was given to Israel in His wisdom and understanding. This is the work of my hands. . . . Mordecai the scribe, from Nitra, in the year [5]602[1841/42]." Indeed, Mordecai Nitra created a work of great originality and daring. He knew it and took delight in his work. The patron similarly appreciated the uniqueness and beauty of the ornaments; the fact that this set survived testifies to its preciousness. Perhaps the miniature Torah scroll itself is also still cherished somewhere in the world.

The Eastern European silversmith, working without legal status and transforming liturgy into motifs, created Jewish objects of great emotive power. The small silver and gold work, carefully placed in its velvet shrine never fails to move the onlooker. How much more did it thrill the small group of worshipers when it was placed on the fabric-wrapped Torah, the bells of its large top-heavy crown ringing as it was moved. What a profound sense of religious devotion it suggests; we feel awed in its presence.

All this and more can we discover by searching for clues in works of art. One must consider what the motif or sign represents, why it is there, what it is saying to us. It may seem surprising that certain Jewish motifs persist throughout centuries and in many countries, but no more surprising than the survival of the Jewish people, its ethics and beliefs, which these motifs embody.

With works of art, the style can tell us what traditions the maker and client knew and preferred. Style is evidence of the prevailing culture and to what extent the Jewish community participated or hoped to participate in that culture. The materials employed tell us what was available to the maker and what the client could afford, although even in the poorest communities silver and gold were preferred for Torah ornaments. In appreciating Jewish works of art, we have the unique opportunity to get in touch with particular people and moments in the history of the Jewish people, surely an exciting enterprise.

C. G.

[1] G. Schoenberger, "A Silver Sabbath Lamp from Frankfort-on-the-Main." In *Essays in Honor of Georg Swarzenski*, edited by Chaim Stern, pp. 189-97. Chicago: Henry Regnery, 1951.
[2] R. Grafman, Study of Early 1700s Jewish Silverwork in Related Frankfurt Workshops. (Work in progress, to appear 1994.)
[3] *Fine European Silver*, Christie's Catalog. Geneva, Wednesday, May 13, 1981, cat. no. 191. (Removed from sale, sold privately.)

CATALOG

GROUP ONE

Five Tower-form Spice Containers (*B'samim* Boxes)

(Figure 1, page 3)

Used to hold the spices which are used during Havdalah, the service on Saturday night which ends the Sabbath, these silver towers are also reminders that spices were a precious commodity in medieval times and were often kept in the town tower for safekeeping. The fine filigree towers are Italian or Polish work influenced by Italian design.

I

Possibly Venice, 18th/19th century

Silver filigree, partly gilt; cutout, castings

H. 16 ⅜ in.

NY/MJS 6

2

Poland, 18th century

Silver; embossed, cast, engraved

H. 9 ¾ in.

Formerly in the Davidowitz Collection

NY/MJS 27

3

Poland, 19th century

Silver filigree; cutout, engraved

H. 16 ½ in.

NY/MJS 5

4

Poland, 1806

Silver filigree, partly gilt; engraved and cutout elements, glass and amber stones.

H. 12¼ in.

Marks: Tardy, p. 329; Rosenberg no. 7875

Formerly in the Zagayski Collection

NY/MJS 15

5

Possibly Venice, 18th/19th century

Silver filigree, partly gilt; castings

H. 14½ in.

NY/MJS 3

6

Maurycy Gottlieb (1856–1879) born in Drohobycz, Poland; died in Cracow

Old Woman in Cap (1877)

Oil on canvas

H. 28 in. W. 24 in.

Literature: N. Guralnik, with E. Kolb and J. Malinowski, *In the Flower of Youth*, 1991, cat. no. 20. *Mult es Jovo*, 1924, p. 267.

NY/MJS 415

The young painter Maurycy Gottlieb has been called "The Jewish Rembrandt." The influence of the master is seen in this work, which can be compared to Rembrandt's *Mother Reading the Bible* of 1629. While both women are reading books, Gottlieb's old woman is dressed in her silver embroidered Sabbath cap and breast cover, worked in the Jewish-Polish folk craft called *spanier arbeit*.

7

Steinhardt/Boller Hanging Sabbath Lamp

(Figure 5, page 9)

Lamp: Frankfurt, after 1706

Master: Johann Adam Boller

Silver; embossed, cutout, chased, castings

L. 24½ in. Diam. of oil containers 14½ in.

Marks: Rosenberg nos. 2054 and 2004

Hanger: Frankfurt, late 18th century

Master: Johann Jacob Löschhorn

Silver; embossed, cast

Marks: Scheffler, *Hessens* no. 294; Rosenberg no. 2004

Literature: G. Schoenberger, "A Silver Sabbath Lamp." 1951, Fig. 3, p. 195. *Fine European Silver,*

Christie's catalog, May 13, 1981, cat. no. 191. (Removed from sale, sold privately.)

Compare: C. Grossman, *A Temple Treasury: The Judaica Collection of Congregation Emanu-El*, 1989, cat. no. 87, pp. 104–106.

NY/MJS 203

This rare Frankfurt silver hanging Sabbath lamp is one of a small group of extant works by this master. Oil spouts encircle the lamp in a star-shaped pattern giving it its popular name, *Judenstern*, a "Jewish star" lamp. This is an early example of the type, which later was somewhat simplified. The candleholders were added when they became stylish and the glides and hanger are replacements. Jews were not permitted to work in German silversmith guilds, but as patrons they did commission works from leading workshops.

8

Shlomo Naftali Passover Banner

South Germany, 19th century

Linen; painted, with drawnwork border and bottom fringe, red silk binding

L. 53 in. (without fringe) W. 15⁹⁄₁₆ in.

In Hebrew: Text from the Passover Haggadah. Shlomo (Solomon) son of Naftali and his wife, Madame Hebe, may she live and be well. In memory of the young deceased Kalman Bachrach from Mansbach.

NY/MJS 135B

Such painted cloths were used as wall hangings and probably to wrap the ceremonial matzot during the Passover Seder. They were often decorated with scenes from the Haggadah.

cat. no. 6

9

Painted Passover Pillow

South Germany, 1832

Linen; painted

H. 32½ in. W. 30¼ in.

In Hebrew: OUTER CIRCLE Hagga-
dah verse concerning Hillel's
eating of matzah with maror;
INNER CIRCLE Order of Seder, date
[5]592 [1832]

NY/MJS 338

While several painted banners
are known in public and private
collections, this is a rare sur-
viving pillowcase painted in the
same style. The pillowcase was
used during the Seder to illus-
trate "reclining at the table" like
a free person (i.e., the Romans).

10

**Steinhardt/Horwitz
Passover Plate (Seder Plate)**

Czechoslovakia, 19th century

Soft-paste porcelain; painted,
glazed

Diam. 14½ in.

In Hebrew: shank bone/ egg/
bitter herb/ for blessing/
haroset/ greens bitter herb/ for
blessing

Literature: *Encyclopaedia Judaica*,
1971–72, vol. 13, Passover, pl. no. 8.

Formerly in the Horwitz
Collection

NY/MJS 201

This lovely dish uses only He-
brew calligraphy to define itself
as a Passover plate. Its colorful
decoration of spring flowers is a
fine example of the type.

cat. no. 9

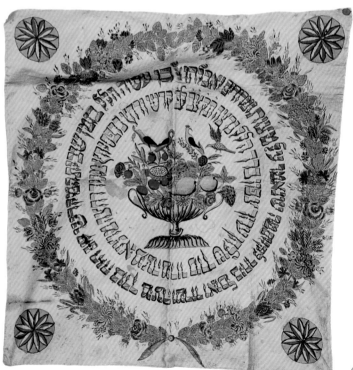

cat. no. 8

11

Venezia Torah Crown and Bells

(Cover illustration)

Venice, first half of 18th century

Master: CL or CI

Silver, partly gilt; embossed, engraved, cutout, inscribed 1871

Crown: H. 8½ in. Diam. 9¼ in.

Bells: H. 19 in. Diam. 5 in.

Marks: Pazzi no. 55 or 56, 245 and 329

In Hebrew on crown and both bells: *Nefesh Shalom* Association, in the year [5]631 [1870/71]

Literature: V. Mann, ed., *Gardens and Ghettos*, cat. no. 208.

Formerly in the Ehrenthal Family Collection

NY/MJS 120 and 208A/B

These ornaments for the Torah were placed atop the fabric covered scroll and paraded down the aisle of the synagogue to the reader's desk. The sight of the top-heavy silver and the sound of the bells added to the drama of the service.

12

Mezuzah and Scroll

Probably Russia, 19th/20th century

Carved wood, painted red; glass window; parchment scroll

Case H. 8⅝ in.

NY/MJS 66A/B

Bronze Hanukkah Wall Lamps (*Hanukiot*)

13

Italy, 16th century

Bronze; cast, engraved

H. 5¹³⁄₁₆ in. W. 6⅞ in. (servant light missing)

In Hebrew: TOP Above God stood the seraphim (Isaiah 6:2) HORIZONTAL BAR For the commandment is a lamp and the teaching is light, and reproofs of instruction are the way of life. (Proverbs 6:23) LOWER SCROLLS Your word is a lamp to my feet/ and a light to my path. (Psalm 119: 105) LOWER LEFT ARM [5]319 [1559]

NY/MJS 98

14

Italy, 17th century

Bronze; cast, crest of Diena family

H. 6⅛ in. W. 9 in. D. 1¼ in. (servant light missing)

In Latin: ON CREST I A C O E . DIENA .H E.

Compare: C. Benjamin, *The Steiglitz Collection*, 1987, cat. no. 123.

Formerly in the Yovely Collection

NY/MJS 103

15

Italy, 17th century

Bronze; cast

H. 6¾ in. W. 8¼ in. (servant light missing)

Formerly in the Davidowitz Collection

NY/MJS 97

16

Poland, early 18th century

Bronze; cast, engraved

H. 7 in. W. 11½ in. (servant light and side pieces missing)

NY/MJS 207

It is fascinating to see how the Polish lamp relates in its form to its earliest Italian counterparts: its openwork back, its scroll design, and its fleur-de-lis finial. The owner of the Polish lamp was a Levy or ha-Levi, as is designated by the engraving of the pitcher used by the Levites to wash the hands of the Temple priests (Kohanim) in Jerusalem.

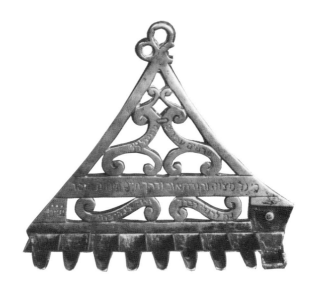

cat. no. 13

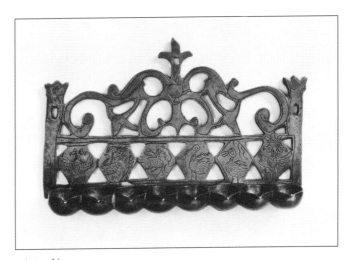

cat. no. 16

top, left to right: cat. nos. 27, 26, 25; bottom: cat. nos. 28, 29

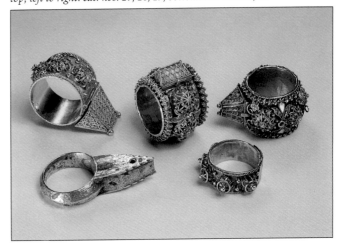

Italian Amulets and Amulet Cases

These amulets and amulet cases were used to hang near a baby's crib or the bed of a woman in childbirth, to protect them from death; some were worn as jewelry. Their precious nature indicates the wealth of the owners and the communities in which they lived.

17

Italy, 19th/20th century

Silver; cast

H. 2½ in. W. 2 in.

In Hebrew: Let no evil befall you. (Psalm 91:10)

Formerly in the Yovely Collection

NY/MJS 81/3

18

Italy, probably 18th century

Silver; cast

H. 3¼ in. W. 1⅞ in.

In Hebrew: *Shaddai* (one of the names of God) / against the Kingdom of Lilith

Formerly in the Yovely Collection

NY/MJS 81/2

19

Italy, probably 17th century

Silver, partly gilt; cast, engraved

H. 3 in. W. 2 in.

In Hebrew: OBVERSE *Adonai* is your keeper, *Adonai* is your shade / on your right hand. / By day the sun will not / smite you, or the moon by night. / *Adonai* will keep you from all / evil; *Adonai* will guard / your soul; *Adonai* will protect / your going out and your coming in / from this time forth and forever. (Psalm 121:5–8) REVERSE *Shaddai* (one of the names of God)

Formerly in the Yovely Collection

NY/MJS 47

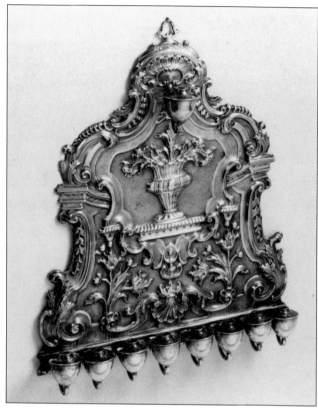

cat. no. 33

top, left to right: cat. nos. 18, 20, 46; middle: cat. nos. 17, 21, 24; bottom: cat. nos. 19, 23, 22

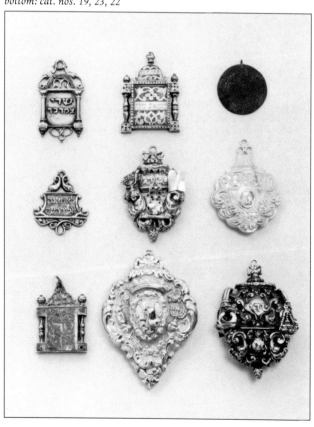

20

Italy, 19th century

Silver; cast, chased

H. 2⅞ in. W. 2⅝ in.

In Hebrew: Crown of Torah. Answer me, O God [who] answers [supplications]. (paraphrase of Psalm 27:7)

Compare: C. Grossman, *A Jewish Family's Book of Days*, 1989, p. July

NY/MJS 81/1

21

Italy, 19th century

Silver; embossed, engraved, castings

H. 3½ in. W. 2⅝ in.

In Hebrew: *Shaddai* (one of the names of God) / Ten Commandments

NY/MJS 46

22

Italy, 18th century

Silver, partly gilt; embossed, engraved, castings

H. 3⅝ in. W. 3¼ in.

In Hebrew: *Shaddai* (one of the names of God)

Formerly in the Yovely Collection

NY/MJS 41

23

Italy, 18th/19th century

Gold; embossed, engraved

H. 4¼ in. W. 3¾ in.

Formerly in the Davidowitz Collection

NY/MJS 45

24

Italy, 19th/20th century

Gold; embossed, engraved

H. 3⅞ in. W. 2⅞ in.

NY/MJS 42

Mazal Tov Wedding Rings

These rings were probably worn during the first seven days of a marriage, when seven evenings of ceremonial blessings are held. Some were personal possessions, but others were probably lent to the bride by the community. The house was both a metaphor for the good wishes to the new couple, and a reminder of the Temple in Jerusalem.

25

House type

Italy, 17th/18th century

Gold; granulation, filigree, cloisonné enamel, engraved

Diam. 1¾ in.

In Hebrew: M[azal] T[ov]

NY/MJS 198

26

House type

Italy, 17th/18th century

Gold; granulation, filigree, engraved

Diam. 1⅜ in.

In Hebrew: Mazal Tov/ Ya'akov, Yetke

NY/MJS 196B

27

House type

Italy, 17th/18th century

Gold; granulation, filigree, engraved

Diam. 1¾ in.

In Hebrew: Mazal Tov

NY/MJS 196A

28

Gothic Synagogue form

Probably Central Europe, date unclear

Bronze, gilt; cast, engraved, pierced

Diam. 2 in.

In Hebrew: M[azal] T[ov]

NY/MJS 197

29

House type

Italy, 17th/18th century

Gold; granulation, filigree, engraved

Diam. 1 in.

In Hebrew: Mazal Tov

NY/MJS 196C

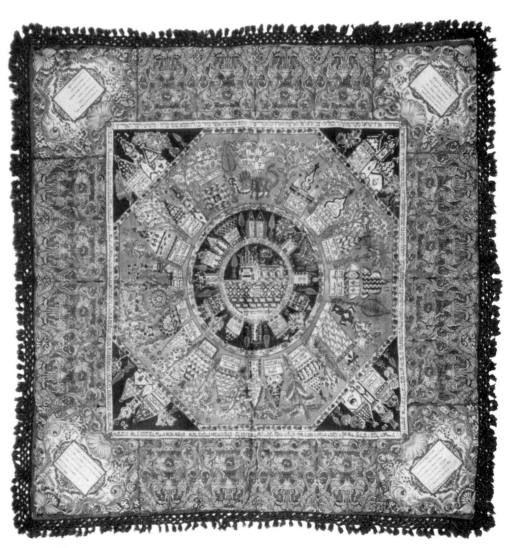

cat. no. 32

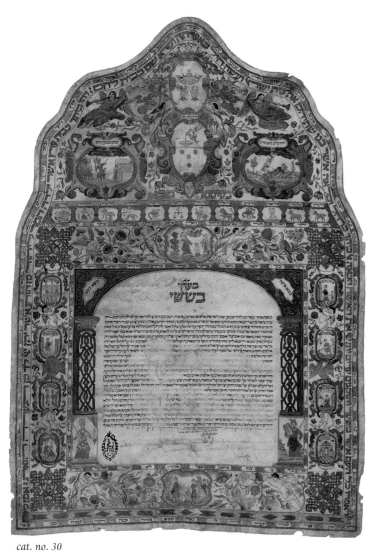

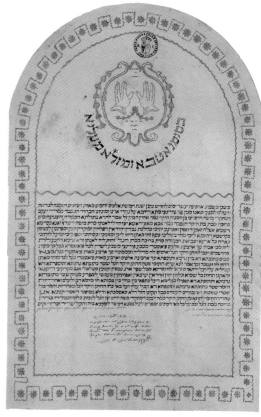

cat. no. 30 *cat. no. 31*

30

Venetian Marriage Contract (Ketubbah)

April 3, 1716 (11 Nisan 5476)

Groom: Yehoshua Aaron ha-Cohen son of Pinhas, son of Rabbi Joseph Azriel ha-Cohen

Bride: Aeli (?) daughter of Menahem, son of Meshulam ha-Levi Meshulomim

Parchment; painted, handwritten.

H. 35⅞ in. W. 25½ in.

Formerly in the Isaiah Shachar Collection.

NY/MJS 321

The union between two important families was documented in this elaborately decorated wedding contract. Included are the coats of arms of both families, with biblical references to the names of the bridegroom and bride.

31

Florentine Marriage Contract (Ketubbah)

April 11, 1808 (14 Nisan 5568)

Groom: Yaakov Moshe Hayim son of Aaron ha-Cohen

Bride: Brucha daughter of Abba from Atsirata

Parchment; illuminated, handwritten

H. 26 in. W. 16¾ in.

NY/MJS 317

32

Souvenir Cloth Map of Jerusalem for Italians

Probably Jerusalem, 19th/20th century

Cotton, printed, with cotton fringe

H. 44 in. W. 42½ in. (without fringe)

In Hebrew: Names of holy places

In Italian: Legend of numbered holy places

NY/MJS 135A

33

Wall Hanukkah Lamp (*Hanukiah*)

Rome, late 17th century

Master: G.V.

Silver; embossed, chased

H. 18 in. W. 15 in. D. 1½ in.

Marks: Master and Rosenberg no. 7432

Formerly in the Zagayski Collection

NY/MJS 185

GROUP THREE

Spice containers (*b'samim* boxes) are the most varied and fanciful forms of Judaica, perhaps because children take part in the Havdalah service. At the close of the Sabbath on Saturday night, blessings are said over spices, candles and wine. Birds, animals, towers, and fruits are among the many charming forms in which these containers are created.

34
Tower-form Spice Container

Bamberg, Germany, late 18th century

Master: Rudolf Weissenfeld

Silver, partly gilt; engraved, pierced, castings

H. 13½ in. Diam. of base 4⁹⁄₁₆ in.

Marks: Rosenberg nos. 1100 and 1132

Formerly in the Davidowitz Collection

NY/MJS 17

35
Tower-form Spice Container

Germany, mid-18th century

Master: IH

Silver, partly gilt; embossed, engraved, cut out, castings

H. 11⅜ in.

Marks: Master

NY/MJS 35

36
Kiddush Goblet

Salzburg, 16th century

Silver, partly gilt; embossed, engraved

H. 6 in.

Marks: Rosenberg no. 7828

NY/MJS 228

37
Yom Kippur Buckle on Woven Silver Belt

Eastern Europe, 19th century

Buckle: Silver; engraved, cutout

H. 2½ in. W. 3⅞ in.

Belt: Silver wrapped bands on cotton core.

L. 28½ in. W. 1⅞ in.

In Hebrew: For on this day / atonement will be made for you / to purify you / of all your sins / will you be purified before *Adonai* (Leviticus 16:30)

Formerly in the Yovely Collection

NY/MJS 55

cat. no. 34

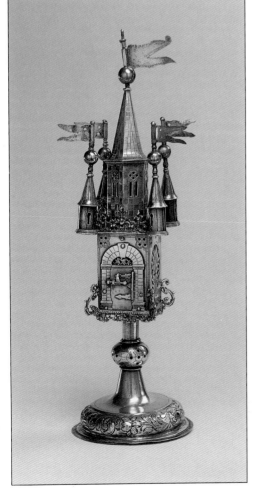

cat. no. 35

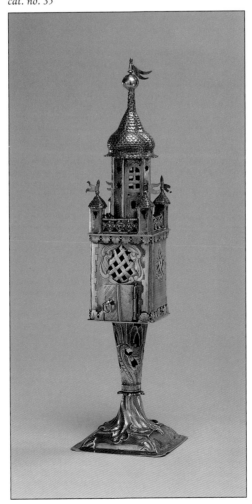

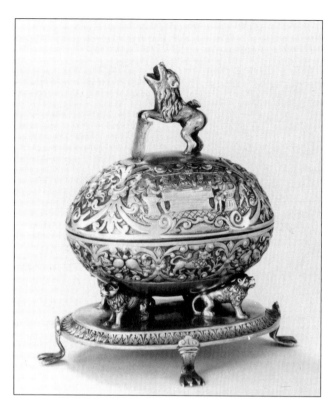

38
Mezuzah Case
New York, 20th century

Master: Ilya Schor

Silver; embossed, engraved, cutout

H. 4½ in. W. 1¼ in.

Marks: Signed by the artist in Hebrew and English

NY/MJS 130

39
Ilya Schor Cigarette Case
New York, 1943

Master: Ilya Schor

Silver and gold; embossed, engraved, cutout. Worked on an older silver cigarette case.

Marks: Signed on case and on dedication

H. 3½ in. W. 3 in. (closed)

In Hebrew: PERIMETER ONE Do not cast us aside/ from before you/ and your spirit of holiness/ do not take from us. (High Holiday liturgy) PERIMETER TWO The heavens are the heavens of *Adonai*, but the earth *Adonai* has given to the sons of men. (Psalm 115:16)

In Yiddish: INTERIOR Yisroel Schor from Zlatchov [Zolochiv] made this for his friend the painter Mane-Katz from Kremenchug in the year 1943 in New York.

Formerly in the Isaiah Shachar Collection

NY/MJS 128

40
Lion Etrog Container
Austria-Hungary, late 19th/early 20th century

Master: F V

Silver, partly gilt; embossed, chased, castings

H. 7½ in. L. 6½ in. D. 5⅛ in.

Marks: Master and Tardy, p.75

In Hebrew: ON SHIELD E[trog] F[our species]

Literature: *Jüdische Lexicon*, 1928, vol. 2, pl. 66, no. 2.

Formerly in the Vienna Jewish Museum

NY/MJS 23

41
Gilded Etrog Container
Danzig, about 1800

Silver, gilt; embossed, cutout, castings

H. 10 in. L. 6 in. D. 4 in.

Marks: Rosenberg no.1530

Literature: *Jüdische Lexicon*, 1928, vol. 2, pl. 66, no. 4.

Formerly in the Vienna Jewish Museum

NY/MJS 22

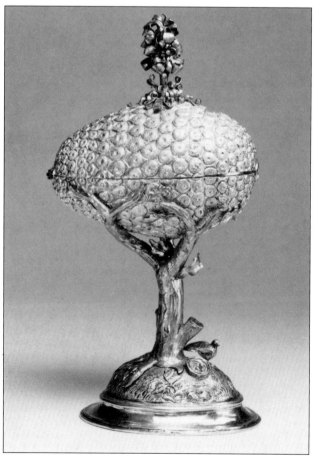

above, left: cat. no. 40
below, left: cat. no. 41
below, right: cat. no. 39

cat. no. 43

42

Double Circumcision Cup

Augsburg, 1791-1793

Master: Christianus Drentwett

Silver, gilt; engraved, chased

a: H. 2 in. Diam. 2 in.

b: H. 2¼ in. Diam. 2⅜ in.

Marks: Rosenberg nos. 284 and 987

In Hebrew: (a) Cup of [wine over which] blessing [is recited]
(b) Cup of aspiration

NY/MJS 8a/b

43

**Circumcision Flask
(for astringent)**

Probably Poland, 18th century

Silver; embossed, engraved, castings

H. 4 in.

Marks: Master (indistinct) and Tardy, p.74

Inscribed with initials of the Mohel (circumciser): A H L

Formerly in the Yovely Collection

NY/MJS 304

44

Tower-form Spice Container

Probably Warsaw, 19th century

Silvered brass; cutout, engraved, filigree ball

H. 11⅛ in.

Formerly in the Davidowitz Collection

NY/MJS 302

Polish-Jewish silversmiths in the nineteenth century worked in their own legal workshops in Warsaw. Their method included some mass production techniques and they employed some base metals such as brass which they silver-plated. On Russian-Jewish silver work we see names in Cyrillic and Russian hallmarks.

45

Tower-form Spice Container

Poland, early 19th century

Silvered brass; engraved, cutout with filigree doors

H. 14½ in.

Marks: ST (?)

In Hebrew: In the year [5]574 [1813/14]

NY/MJS 16

46

Amulet Medallion

Europe, possibly 16th century

Bronze, cast

Diam. 2 in.

In Hebrew: Names of angels and names of God

Compare: C. Benjamin, *The Steiglitz Collection*, 1987, cat. no. 270

NY/MJS 225/30

47

Pear Cluster Spice Container

Poland, 18th/19th century

Silver; cast, tooled

L. 3½ in.

Compare: C. Grossman, *The Jewish Family's Book of Days*, 1989, p. Feb.

Formerly in the Yovely Collection

NY/MJS 36

48

Pear-shaped Spice Container

Poland, 19th century

Silver; engraved, pierced, castings

L. 3 in.

NY/MJS 37

49

**Filigree Pear-shaped
Spice Container**

Poland, 19th/20th century

Master: DF

Silver; filigree, solid twisted handle

L. 6¼ in.

Marks: Master

NY/MJS 33

50

Pear-shaped Spice Container

Kronstadt, Austria-Hungary, 1800

Silver, partly gilt; embossed, cutout, castings

H. 9½ in.

Marks: Tardy, p. 65

NY/MJS 31

51

Pear-shaped Spice Container

Probably Warsaw, 19th century

Master: Brinker

Silver, gilt; engraved, castings

H. 7 in.

Marks: Master and Lileyko, p. 99

Formerly in the Davidowitz Collection

NY/MJS 65

52

Miniature Casket Spice Container

Amsterdam, 18th century with 20th century internal additions

Silver, cast openwork sections

H. 2 in. W. 2 in. D. 1¼ in.

Marks: Tardy, pp. 308, 321 and 322

NY/MJS 32

53

Ram-in-the-thicket Spice Container

Probably Israel, 20th century

Silver; embossed, engraved, castings, semi-precious stones

H. 5½ in. W. 2¼ in. D. 1⁹⁄₁₆ in.

In Hebrew: And behold one ram was caught by his horns in the thicket. (Genesis 22:13)

For archaeological original on which this is based: C.L. Wooley, "Ur Excavations," 1934, vol. 2, pl. 87.

NY/MJS 88

54

Bird-on-a-perch Spice Container

Augsburg, late 17th or early 18th century

Master: LR (?)

Silver, partly gilt; embossed, engraved, with amethyst

H. 6½ in.

Marks: Rosenberg nos. 208 (?) and 772 (?)

NY/MJS 89

clockwise from left: cat. nos. 54, 51, 45, 44, 50, 53, 49, 52, 48

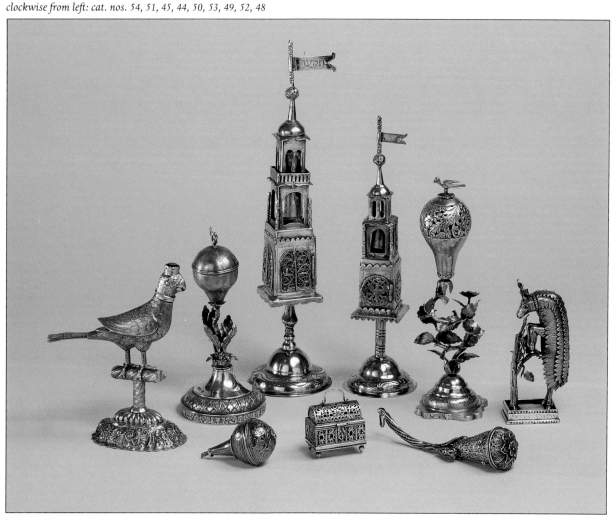

cat. no. 64

GROUP FOUR

55

Three-tiered Passover Plate

Vienna, 1866–1872

Master: AW

Silver; embossed, chased, castings.
Curtain a replacement with
original gold braid trim

H. 21¼ in. (including figures)
Diam. 16 in.

Marks: Master and Rosenberg
no. 7864

NY/MJS 117

cat. no. 60

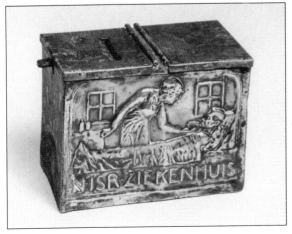

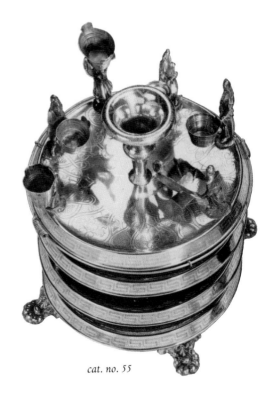

cat. no. 55

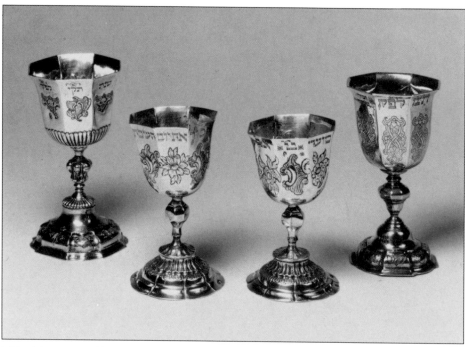

left to right: cat. nos. 59, 58, 57, 56

56

Kiddush Goblet for Sabbath

Augsburg, 1736/37

Master: Bartholomäus Heuglin

Silver, gilt; embossed, engraved

H. 5¼ in.

Marks: Rosenberg nos. 239 (partial) and 903

In Hebrew: Remember the Sabbath day to keep it holy. (Exodus 20:8) Observe the Sabbath day to keep it holy. (Deuteronomy 5:12) In the year [5]496 [1735/36]

NY/MJS 10

57

Kiddush Goblet for Festivals

Augsburg, mid-18th century

Master: Hieronymus Mittnacht

Silver, gilt; embossed, engraved

H. 4⁹/₁₆ in.

Marks: Rosenberg nos. 915, 7875 and unclear city mark

In Hebrew: And Moses declared God's festivals to the children of Israel. (Leviticus 23:44)

Formerly in the Davidowitz Collection

NY/MJS 9

58

Kiddush Goblet for Sabbath

Augsburg, 1761–1763

Master: Hieronymus Mittnacht

Silver, gilt; embossed, engraved

H. 4⁹/₁₆ in.

Marks: Rosenberg nos. 263, 915 and 7884

In Hebrew: Remember the Sabbath day to keep it holy. (Exodus 20:8) Observe the Sabbath day to keep it holy. (Deuteronomy 5:12)

Formerly in the Davidowitz Collection

NY/MJS 13

59

Kiddush Goblet for Passover

Augsburg, 1747–1749

Master: IM

Silver, gilt; embossed, engraved

H. 5½ in.

Marks: Rosenberg nos. 252 and 953

In Hebrew: And I will save you from their bondage. (Exodus 6:6) In the year [5]510. [1749/50]

Formerly in the Ettinghausen Oxford Collection

NY/MJS 12

60

Charity Box

Holland, 1919

Maker: M.R. Jacobson

Copper; embossed, cut slot, stamped number on base

H. 3¾ in. W. 5³/₁₆ in. D. 2¹⁵/₁₆ in.

In Dutch: New Jewish Hospital

Compare: M.H. Gans, *History of Dutch Jewry*, 1971, p. 83.

NY/MJS 108

61

Miniature Torah Shield

Poland, 18th century

Silver, partly gilt; embossed, engraved, castings (head of rabbit on upper right is replacement)

H. 5⅜ in. W. 4½ in.

Marks: Tardy, p. 63 (?)

In Hebrew: Tablet of the Sabbath/Tablet of the Holy Day

Formerly in the Davidowitz Collection

NY/MJS 183

62

Prayerbook in Tortoiseshell Binding

Book: in Spanish, printed in Amsterdam, 1656, with hand painted endpapers and gilt edges

Binding: Tortoiseshell with silver castings

H. 3½ in. W. 2⅝ in. D. 1⅜ in.

Formerly in the Davidowitz Collection

NY/MJS 51

63

Pidyon-ha-Ben Plate

Lemberg, mid-18th century

Silver, embossed

H. 8¾ in. W. 11⅝ in.

Marks: Tardy, p. 65 and Rosenberg no. 7884

Literature: G. Schoenberger and T.L. Freudenheim, *The Silver and Judaica Collection of Mr. and Mrs. Michael M. Zagayski*, 1963, cat. no. 184.

Formerly in the Zagayski Collection

NY/MJS 38

64

Steinhardt Esther Scroll (*Megillat Ester*)

Central Europe, 18th century

Parchment, hand-colored engraving with handwritten text

H. 8¼ in. L. 71 in.

Compare: C. Benjamin, *The Steiglitz Collection*, 1987, cat. no. 188.

The border images below the text on this scroll are illustrations of the Purim story, and the vignettes above are portraits of the various personages in the story. Such printed decorative borders were acceptable but the biblical text was handwritten by a scribe.

NY/MJS 90

65

Torah Shield (*Tas*)

(Figure 9, page 12)

Augsburg, 1747–1749

Master: Hieronymus Mittnacht

Silver, gilt; embossed, engraved

H. 13¾ in. W. 12 in.

Marks: Rosenberg nos. 252 and 915

In Hebrew: CENTER PLAQUE H[oly] S[abbath] LOWER MEDALLION Rabbi Shmuel Katz s[on of the] r[espected] Yosef Yehezkel, the [memory of the] r[righteous be a] b[lessing], and his wife Feigel, m[ay] s[he live]. In the year [5]509 [1748/49].

NY/MJS 170

66

Torah Shield (*Tas*)

Augsburg, 1800

Master: Franz Anton Gutwein

Silver, gilt; embossed, engraved, castings

H. 14 in. W. 9 in.

Marks: Rosenberg nos. 289 and 999

In German: TOP In memory of their beloved parents ALONG RIGHT David Levi and his wife Mathilde, née Weil ALONG LEFT Joseph Levi and his wife Gida, née Stern BASE gift of Max Levi, Stuttgart, now in Paris; Carl Levi, Stuttgart/ 1930

In Hebrew: In the year [5]560 [1800]. PLAQUE Passover

Formerly in the Toporowitch Collection

NY/MJS 173

67

Torah Shield (*Tas*)

Poland, early 19th century

Master: KL

Silver, gilt; embossed, castings (missing two pendants)

H. 12½ in. W. 9¼ in.

Marks: Master and Tardy, p. 60

Formerly in the Davidowitz Collection

NY/MJS 165

68

Torah Shield (*Tas*)

Probably Breslau, early 19th century

Master: CZ

Silver; embossed, engraved

H. 12 in. W. 10⅜ in.

Marks: Master and indistinct place and date

In Hebrew: A gift to the synagogue according to the wishes of Michael Katz, [may his] m[emory be a] b[lessing] on the first anniversary. In the year [5]599. [1838/39] Presented by his wife Madam Hannah m[ay] s[he live] to memorialize his name. PLAQUE Sukkot

NY/MJS 171

69

Torah Shield (*Tas*)

Poland, 1787

Silver, partly gilt; embossed, engraved, with semi-precious stones

H. 9¾ in. W. 7⅞ in.

In Hebrew: CENTER MEDALLION T[his is the] g[ift] of o[ur] t[eacher and] rabbi, R[eb] Shmuel e[xemplar of our] a[ge], s[on of] R[abbi] Ya'akov Kopel, the [memory of the] r[righteous be a] b[lessing]. LOWER MEDALLION Sunday/ New Moon of/ Tammuz, in the year [5]547 [1787].

Formerly in the Yovely Collection

NY/MJS 166

70

Miniature Torah Shield (*Tas*)

Poland, 1739/40

Silver, gilt; embossed, castings

H. 6¼ in. W. 4½ in.

In Hebrew: [5]500 [1739/40]

Marks: Lileyko, pp. 99 and 100

Formerly in the Davidowitz Collection

NY/MJS 182

71

Torah Shield (*Tas*)

(Figure 6, page 10 and Figure 7, page 11)

Frankfurt, late 17th/early 18th century

Master: Johann Valentin Schüler

Silver; cast sections, soldered; hanger missing ornament

Shield: H. 10 in. W. 10 in.

Hanger: H. 4 ½ in. W. 1 ¾ in.

Marks: Rosenberg no.2006 and Scheffler, *Hessens* no. 302; (see ill. for VS in heart shape; Schoenberger describes the mark in "A Silver Sabbath Lamp," p. 189, note 6.)

In Hebrew: ON PLAQUE S[hemini] A[tseret]/ S[imhat] T[orah]

NY/MJS 168

These Torah ornaments made in great German non-Jewish silver workshops and in Eastern Europe by unlicensed Jewish silversmiths are among the most stylized objects of Judaica. Clear styles of ornamentation and symbolism enable us to trace their origins. This Frankfurt shield (cat. no. 71) is made of blocks of cast silver which create a lyrical patterning of form that is related to the production of a small group of silversmiths working in the early years of the 18th century. It is one of the few examples of this kind of work remaining in the world.

cat. no. 66

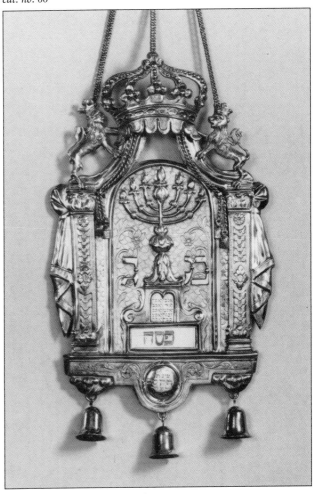

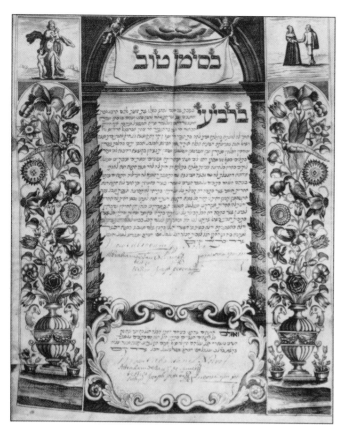

cat. no. 72

73

Miniature Torah Crown and Shield in Box (*Keter* and *Tas*)

(Figure 10, page 12)

Nitra, Slovakia, 1842

Master: Mordechai, the scribe and FF

Silver, gilt; embossed, engraved, castings, with pearls, garnets, and peridots

Crown: H. 6⅛ in. W. 4 in. D. 3¼ in.

Shield: H. 5 in. W. 4 in.

Marks: Master

In Hebrew: TOP OF CANOPY It is a tree of life . . . (Proverbs 3:18) BELLS Praise God with the blast of the horn; praise God with the psalter and harp. Praise God with the timbrel and dance; praise God with stringed instruments and the pipe. (Psalm 150:3,4) And Moses took the book of the covenant, and read in the hearing of the people; and they said, "All that *Adonai* has spoken, we shall do and we shall obey." (adapted from Exodus 24:7) Length of days are in her right hand; in her left hand are riches and honor. (Proverbs 3:16) Blessed be You who in Your holiness gave the Torah to Your people Israel. (Liturgy) SHIELD And let them make Me a sanctuary that I may dwell in their midst. (Exodus 25:8) CHAIN And you shall make a plate of pure gold . . .(Exodus 28:36) WHEEL COVER Speak to the c[hildren of] I[srael] . . . festivals which you shall call a holy convocation for *Adonai*. (pastiche) BOTTOM See [here] something new which never existed since the time the Torah was given to I[srael] in His wisdom and understanding. This is the w[ork of my] h[ands] . . . Mordecai the scribe, from Nitra, in the year, "riches and honor."

(chronogram) = [5]602 [1841/42]

Literature: G. Schoenberger and T.L. Freudenheim, *The Silver and Judaica Collection of Mr. and Mrs. Michael M. Zagayski*, 1963, cat. no. 22.

Formerly in the Zagayski Collection

NY/MJS 2

72

Amsterdam Marriage Contract (Ketubbah)

November 30, 1696 (2 Kislev 5456)

Groom: Mosseh son of Yitzhak Abrabanel Aredes

Bride: Lea daughter of Joseph Abenhacar da Costa

Parchment, engraved and handwritten

H. 15⅜ in. W. 12⅝ in.

Compare: S. S. Kayser and G. Schoenberger, *Jewish Ceremonial Art*, 1955, cat. no. 169.

This is an early example of the engraved Dutch type of kettubah. Some, perhaps later, are engraved with a commemorative to Rabbi Isaac da Fonseca Aboab.

NY/MJS 325A

cat. no. 74

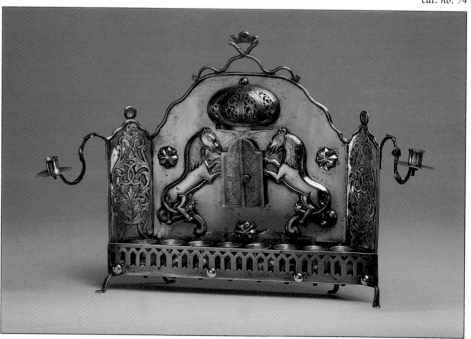

74

Lion Hanukkah Lamp
(*Hanukiah*)

Crakow, 1847

Silver, partly gilt; cutout, engraved, castings

H. 9 in. W. 10½ in. D. 2⅝ in.

Marks: Tardy, p. 328

NY/MJS 156

75

Nuremberg Hanukkah Lamp
(*Hanukiah*)

Nuremberg, 1776–1780

Master: Johann Nicolas Wollenberg

Silver; embossed, engraved

H. 8¾ in. W. 10 in. D. 3¾ in.

Marks: Rosenberg nos. 3775 and 4298

In Hebrew: PLAQUE First [light] of Hanukkah

Formerly in the Ettinghaus Oxford Collection

NY/MJS 157

76

Mozart Hanukkah Lamp
(*Hanukiah*)

Frankfurt, late 18th century

Master: (?)M

Silver; embossed, engraved

H. 6¾ in. W. 7¾ in. D. 4½ in.

Marks: Master and Rosenberg no. 2016

Formerly in the Davidowitz Collection

NY/MJS 162

Naming the Frankfurt type of Hanukkah lamp "Mozart" relates it to harpsichord and chamber music, which the form of this lamp recalls. Silver Hanukkah lamps from Northern Europe of the late 18th and 19th centuries are elegant expressions of a lifestyle of many German, Swiss, French, and English Jewish communities.

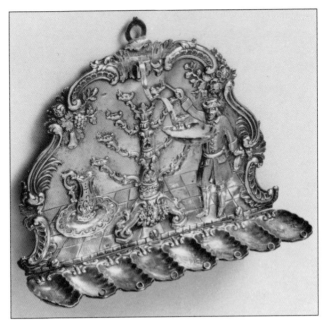

cat. no. 77

77

Spoon Hanukkah Lamp
(*Hanukiah*)

Probably Dresden before 1807

Silver, embossed

H. 8½ in. W. 10 in. D. 6¼ in.

Marks: Rosenberg nos. 7876 and 7884

Compare: M. Narkiss, *The Hanukkah Lamp,* 1939, p.63, drawing of lamp, identified as Dresden 1761, in Berlin Jewish Museum.

NY/MJS 158

cat. no. 75

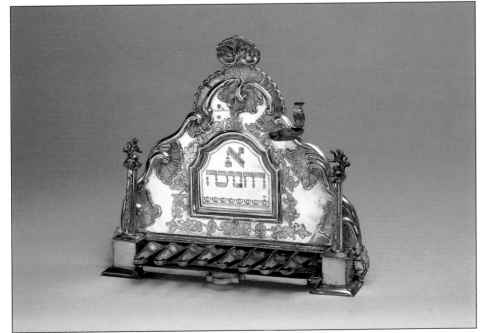

Torah Pointers (*Yadot*)

Pointers are used for the reading of the Torah scroll to avoid touching and smudging the sacred parchment.

78

Eastern Europe, 19th century

Wood; carved and painted; iron nails

L. 9 in.

Formerly in the Yovely Collection

NY/MJS 179

79

Poland, 19th century

Silver; embossed, engraved, cutout, cast hand

L. 8¼ in.

In Hebrew: Moses son of the h[onorable] r[abbi]/ Shmuel Zanvil

NY/MJS 176

80

Poland, 19th century

Silver; cutout, engraved, wire, castings

L. 12¼ in.

In Hebrew: And Israel saw the great hand. (chronogram based on Exodus 14:31) = [5]590 [1829/30]

Formerly in the Davidowitz Collection

NY/MJS 174

81

Breda, Holland; 17th century

Silver, partly gilt; embossed, engraved, castings, with rose diamonds

L. 13⅞ in.

Marks: Voet, p.6

Formerly in the Zagayski Collection

NY/MJS 175

82

Probably Danzig, 18th/19th century

Silver; cast, engraved

L. 6¾ in.

NY/MJS 178

83

Vienna, late 19th/early 20th century

Silver, partly gilt; chased, castings

L. 6½ in.

NY/MJS 180

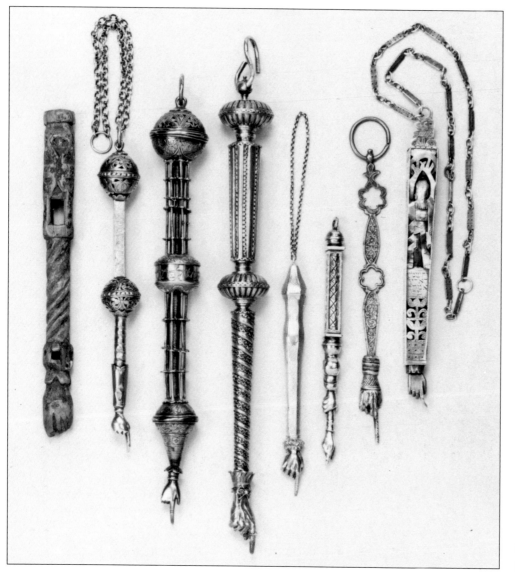

left to right: cat. nos. 78, 79, 80, 81, 83, 82, 84, 85

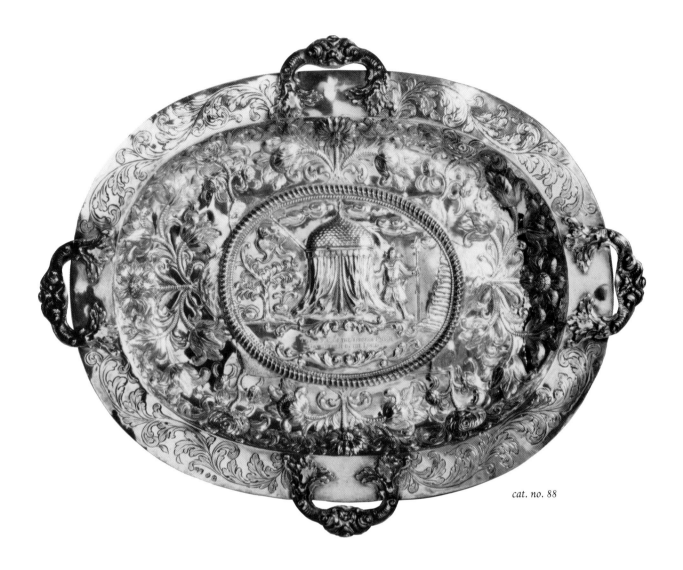

cat. no. 88

84

Morocco, 19th/20th century

Silver; cast, engraved

L. 8 in.

In Hebrew: Donated for [the peaceful] repose of the excellent, praiseworthy, wealthy, p[ursuer of righteousness], the l[earned (?)] Horoafrani, m[ay his] s[oul be] b[ound] up in the b[onds of] life.

NY/MJS 177

85

New York, 20th century

Master: Ilya Schor

Silver; engraved, cutout

L. with chain 20 in.

Marks: Signed by the artist in Hebrew and English

NY/MJS 129

86

Pewter Passover Plate (Seder Plate)

(Figure 3, page 6)

Probably Central Europe, 18th century

Engraver: anonymous Polish artist

Pewter; rolled, hand-etched

Diam. 16 in.

In Hebrew: Order of the Seder/ Shmuel and Raika

NY/MJS 186

87

Paul Klee (1879–1940)

Switzerland

Maske rote Jude (1933)

(Figure 4, page 8)

Charcoal, colors mixed with gum and applied with a blade on paper

H. 16½ in. W. 11½ in.

Signed Klee, upper right

Formerly in the Cecil Michaelis Collection

NY/MJS 422

Note the nervous line drawing on the pewter plate that is exhibited adjacent to Paul Klee's drawing of *Maske rote Jude (Red Jew Mask)*. Both the anonymous local craftsperson and the famous artist use line and symbolism to create a personal expressive transformation of reality.

88

Lord Mayor's Salver

London, 1719

Master: Robert Hill

Silver; embossed and engraved, with four cast handles; emblem of the Spanish and Portuguese Synagogue in London (Bevis Marks)

H. 11⅛ in. L. 26⅝ in.

Marks: *Jackson's Silver & Gold Marks,* p. 165; Tardy, pp. 247 and 249

Probably from the Spencer Churchill Collection

NY/MJS 339

From 1679 to 1779 the Spanish-Portuguese Jewish community in London presented a silver salver to each new Lord Mayor. This presentation tray is one of those gifts.

Jews of North Africa, Persia, and
Yemen have created their
Jewish objects in the style of the
Islamic world, of which they
have been a part since the
destruction of Jerusalem and, in
the case of Yemen, even earlier.
Both their synagogues and their
decorations quote the architec-
ture and design motifs of their
milieu: a cloth completely cov-
ered with designs, ornaments
for the Torah with Islamic
arches, and casting methods for
brass still in use today in North
Africa.

Exhibition installation: Groups six, five and partial four

89

Hanukkah Lamp

Probably Tangiers, 19th/20th
century

Brass, cast

H. 8½ in. W. 8½ in.

NY/MJS 141

90

Hanukkah Lamp

Probably Meknes, 18th/19th
century

Brass; cast, engraved

H. 12½ in. W. 8½ in. D. 1½ in.

Oil row and servant light are
replacements

NY/MJS 134

91

Sabbath Tablecloth

Persia, 18th/19th century

Cotton; embroidered with
colored silk thread and sequins,
metallic fringe

Diam. 32 in.

In Hebrew: Rabbi Shimon says:
"Three who have eaten together
and exchanged of Torah, it is as
though they have eaten from
God's own table, as Scripture says
(Ezekiel 41:22) 'He said to me,
This is the table in the presence of
Adonai.'" (Pirkei Avot 4:3)
(additional unclear passages
probably from Pirkei Avot.)

Compare: B. Kirshenblatt-
Gimblett and C. Grossman, *Fabric
of Jewish Life*, 1977, cat. no. 174.

NY/MJS 328

Torah Finials (*Rimonim*)

(Figure 8, page 12)

92

Morocco, 19th century

Silver, partly gilt; embossed,
engraved, cutout, castings, red
and blue velvet behind glass

H. 11¾ in.

NY/MJS 119a/b

93

Probably Morocco, 19th century

Silver; cast, engraved: parchment
inscribed in ink, glass

H. 11 in.

In Hebrew: A AND B A gift of
Mamon/ daughter of Eli (?)
ha-Cohen

NY/MJS 121a/b

94

Glass Bottle

Probably Damascus, 19th century

Red glass, molded and etched

H. 8 in. W. 6 in.

In Hebrew: BODY Text of Psalm
23, with the end of verse 6 missing
ON HANDLE Mordecai the physi-
cian (variant spelling) ON NECK
Undeciphered Arabic inscription

NY/MJS 49

This bottle may have been used
to hold medicines; the use of
Psalm 23 that includes "restores
my soul" suggests the invoca-
tion of restorative powers.

cat. no. 90

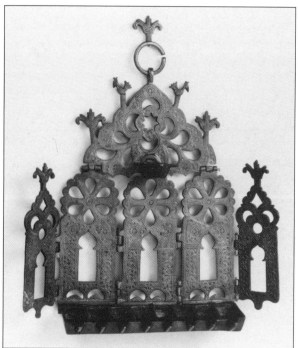

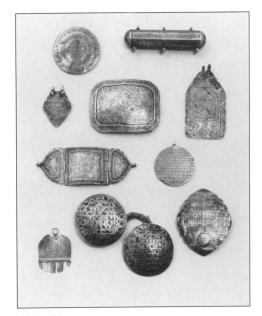

cat. no. 96

96

A group of Hebrew amulets made of silver and brass, from Tunisia, North Africa, Yemen, Persia, and the Holy Land, probably dating from the 18th to the 20th century. Part of Jewish folk culture, these amulets invoke many of God's names for protection against death and disease, and occasionally ask for fertility, a loved one, or the safekeeping of loved ones.

95

Passover Plate (Seder Plate)

Inscribed on the back: Pesaro, 1622; signed Yitzchak Cohen (in Hebrew)

Majolica; painted, glazed

Diam. 18³/₁₆ in.

In Hebrew: Psalm 114 (in its entirety); Order of Seder; Ten Plagues; Passover/ Matzah/ Bitter herbs; WITHIN THE LARGE CARTOUCHES Seder at Bnai Brak/ Rabbis, the time has come; Abraham and the angels/ and he raised his eyes and saw [a ram] (Genesis 22:13); WITHIN THE SMALL CARTOUCHES Moses/ Aaron/ David/ Solomon

Literature: V.B. Mann, "Forging Judaica," 1990, pp. 201-226.

Formerly in the Morpurgo Collection, Trieste

NY/MJS 202

A group of about thirty related plates with 17th century dating have been said to be 19th century forgeries. This plate, however, has an excellent provenance and has been subjected to a thermoluminescence test that apparently verifies its age.

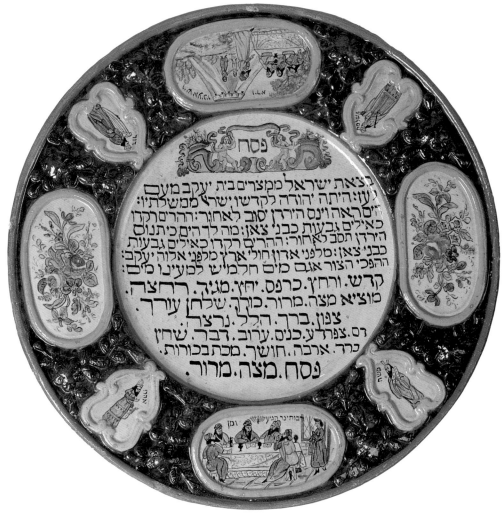

cat. no. 95

GROUP SIX

Archaeological and modern objects from the Land of Israel are visible evidence of the long and profound attachment of the Jewish people to the Land of Israel.

97

Ancient Pottery from Land of Israel

Clay; fired, painted, incised

Plain and decorated vessels: bowls, pilgrim's flask, jugs

NY/MJS 429, 428, 431, 430, 432

98

Leopold Krakauer (1890–1954) Israel, born in Vienna

Crown of Thorns (before 1954)

Drawing, charcoal on paper

H. 20½ in. W. 29½ in.

Signed Krakauer, in charcoal, right

NY/MJS 421

99

Elijah Cup

Israel, 1960s

Master: Albert Dov Sigal (1912–1970)

Silver; engraved, with colored cloisonné enamel sections

H. 5 in.

In Hebrew: BENEATH RIM Cup of Elijah ABOVE BASE In every generation; one should look upon oneself as if personally delivered from Egypt. (from the Passover Haggadah) FOUR ENAMELS LABELLED: Wise/ Evil/ Simple/ The One Who Does Not Know to Ask

NY/MJS 48

100

Recordbook *(Pinkas)*

Jerusalem, 1885

Paper; painting, written in ink; stamped leather binding

H 13⅝ in. W. 8⅜ in. D. 1 in.

NY/MJS 433

This book records in Hebrew and Yiddish the names of contributors to a fund on behalf of building housing for the poor in Jerusalem; listed alphabetically and with a special women's section.

101

Jerusalem Seal Kiddush Cup *(Becher)*

Poland, late 19th century, engraved in Palestine

Silver, engraved

H. 2¾ in. Diam. of rim 2⅜ in.

Marks: Lileyko, p.99

In Hebrew: SCENES LABELED Cave of Machpelah/ One hundred kings of the House of David/ Western Wall

NY/MJS 14

102

Collection Plate

Probably Europe, late 19th century

Lead, cast

Diam. 8¼ in.

In Hebrew: OUTER CIRCLE If I forget you, O Jerusalem.../ at the head of my joy (Psalm 137:5) ABOVE CENTER For her servants take pleasure in her stones and love her dust (Psalm 102:15) CENTER For the sake of Zion BELOW CENTER For the love of Zion and never forget (pastiche)

NY/MJS 414

103

Hebrew Symbol Bottle

Probably Jerusalem, 1st/6th century C.E.

Amber glass; molded, hexagon-shaped

H. 3¼ in. Diam. 3 in.

Three panels with molded geometric decoration and three panels with Jewish symbols: the menorah, the arch, the palm tree

Formerly in the Davidowitz Collection

NY/MJS 111

104

Menorah Stamp Seal

Byzantium, 4th/7th century C.E.

Copper alloy; cast

H. 1⅝ in. W. 2⅜ in. D. 1½ in.

Literature: D.M. Friedenberg, "The Evolution and Uses of Jewish Byzantine Stamp Seals," 1993 (forthcoming).

NY/MJS 110A

Such stamps were used to mark the seals of wide-mouthed stoppers of amphorae, in this case probably to designate wine for Jewish use.

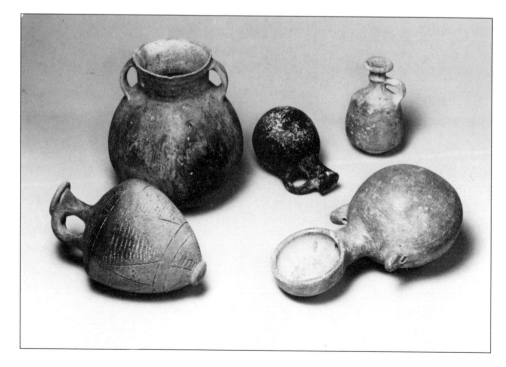

cat. no. 97

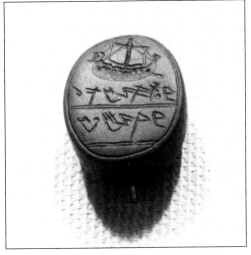

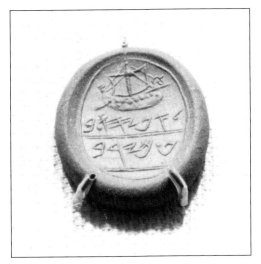

cat. no. 107 *cat. no. 107a*

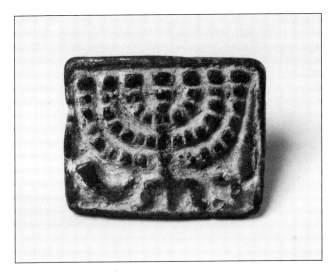

105

**Scroll of Esther in Case
(Megillat Ester)**

Jerusalem, Bezalel School, 1920s

Case: Silver; appliquéd, filigree

In Hebrew: Bezalel/ Jerusalem

H. 7½ in.

NY/MJS 94B

106

**Scroll of Esther in Case
(Megillat Ester)**

Jerusalem; Bezalel School, 1920s

Case: Silver; appliquéd filigree,
casting

H. 5 in.

NY/MJS 125

107

**Ancient Hebrew
Sailing Ship Seal**

Jasper; hand carved

Probably Northern Israel, 8th/7th
century B.C.E.

H. .31 in. (8mm)

In Hebrew: Belonging to
Oniyahu/ Son of Merab

Literature: N. Avigad, "A Hebrew
Seal Depicting a Sailing Ship,"
1982, pp. 59–62.

NY/MJS 501A

This ancient Hebrew seal is a
unique object; it was carried on
a string which was threaded
through the hole and used to
impress the seal of documents.
The use of the sailing ship as an
emblem possibly represents the
owner as a ship owner or, as has
been conjectured by Nahman
Avigad, it may be a rebus on the
owner's name ("God is my
ship").

107A

**Impression of Hebrew
Sailing Ship Seal**

NY/MJS 501B

108

**Modern Israel Shekel with
Image of Sailing Ship**

Silver, 1985

Israel Government Coins and
Medals Corp.

NY/MJS 502

above: cat. no. 104 obverse
below: cat. no. 104 reverse

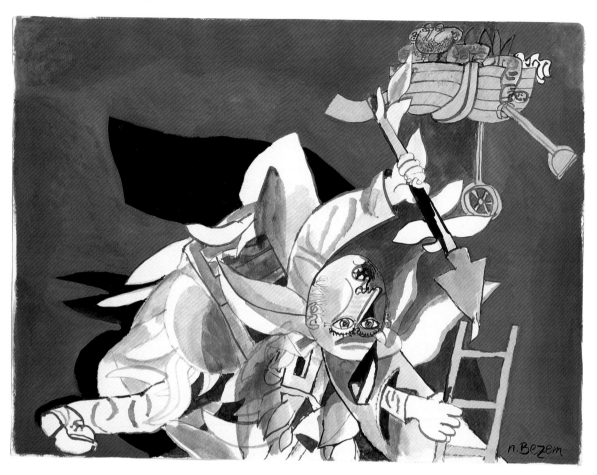

cat. no. 111

cat. no. 114

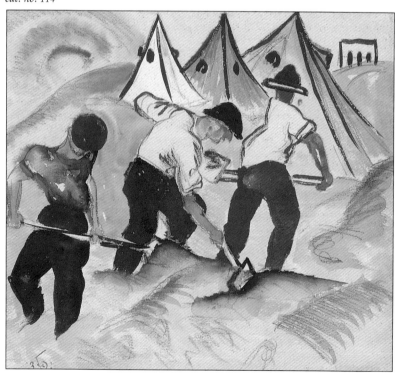

109

Anna Ticho (1894–1980)
Israel, born in Brno,
Czechoslovakia

Landscape of Jerusalem (1954)

Drawing, charcoal on paper

H. 21 in. W. 15 in.

Signed A. Ticho, in pencil, lower
left

NY/MJS 420

110

Yoseph Zaritsky (1891–1985)
Israel, born in the Ukraine

Kibbutz Jehem (1980)

Watercolor and pencil on paper

H. 12 in. W. 10½ in.

Signed Zaritsky in Hebrew and
English, in red and blue ink lower
left; dated in upper right 80/6/1

NY/MJS 418

111

Naftali Bezem (born 1924)
Israel, born in Essen

Figure with Ladder (undated)

Gouache on paper

H. 18 in. W. 23¾ in.

Signed N. Bezem, in lower right

NY/MJS 419

112

Marcel Janco (1895–1984)
Israel, born in Bucharest

Wounded Soldier (undated)

Gouache on paper

H. 7½ in. W. 5¼ in.

Signed M. Janco, in ink, lower
right

NY/MJS 427

113

Anna Ticho (1894–1980)
Israel, born in Brno,
Czechoslovakia

Seated Woman (undated)

Drawing, watercolor and ink on
paper

H. 10¾ in. W. 9⅘ in.

Signed A. Ticho, in pencil, lower
right

NY/MJS 417

114

Israel Paldi (1897–1979)
Israel, born in Berayansk, Russia

Men Working the Land
(undated)

Watercolor, pencil, on paper

H. 8½ in. W. 9½ in.

Signed Y. Paldi in Hebrew, lower
left

NY/MJS 425

115

Reuven Rubin (1893–1974)
Israel, born in Romania

Mother and Child with Basket
(undated)

Watercolor, pencil, on paper

H. 13½ in. W. 11 in.

Signed Rubin in Hebrew and
English, lower left

NY/MJS 426

116

Abel Pann (1833–1963)
Israel, born in Kreslavka, Latvia

Cain and Abel (undated)

Pencil on paper

H. 6 in. W. 7½ in.

Signed Abel Pann, lower right

NY/MJS 424

117

Ephraim Moses Lilien (1874–1925)
Austria, born in Drohobycz,
Poland

*Man Plowing the Land
with Camel* (undated)

Ink, pencil, gouache, on paper

H. 12 in. W. 10½ in.

Unsigned

NY/MJS 423

Works by early painters in Israel
projected their romanticism of
"The Land," embodying the
early visions of Zionism.
Personages of biblical inflection
often were infused with the
idealization of labor. Ticho, of
course, recorded the hills of
Jerusalem as over time she
became one with them, and
Bezem used the Bible to express
his experience of the Holocaust.

**Charity Boxes
(Tzedakah Boxes)**

(Figure 2, page 5)

118

Synagogue-shaped

Germany or Czechoslovakia (?),
19th century

Brass, tin; engraved

H. 7½ in. W. 7¼ in. D. 3¾ in.

In Hebrew: Consoling Mourners/
Society

NY/MJS 411

119

Open Palm-form

Unknown origin, 19th/20th
century

Bronze hand; cast, engraved on
wood base (lid)

Hand: H. 2 in. D. 4 in. L. 8 in.

NY/MJS 400

120

Coin Box

Hungary, inscribed 1863/64

Tin, brass, silver

H. 8 in. W. 6½ in. D. 4 in.

In Hebrew: Holy [Burial] Society
of the H[oly] C[ongregation] of
Orashaza, the year [5]624 [1863/
64]

NY/MJS 412

121

Art Moderne Coin Box

Holland, 20th century

Master: G.R.

Bronze; cast

H. 6¾ in. W. ¹¹⁄₁₆ in. D. 5¼ in.

In Hebrew: Jewish National Fund

NY/MJS 410

122

Lion Tankard-form

Budapest, 1836; inscribed 1876

Master: KL

Silver; engraved, embossed,
appliqué, casting

H 9 in. Diam. 4½ in.

Marks: Rosenberg nos. 9400
and 9399

In Hebrew: Charity saves from
death (based on Proverbs 10:2)

In Hungarian: Holy Burial
Society/ Avraham Apam, Jozsef
Hirsh, officers, Aug. 1876

NY/MJS 404

123

Institutional Coin Box

Probably Holland, 20th century

Tin; painted black with white
inscription

H. 5¼ in. W. 4⅛ in. D. 4⅜ in.

ON TOP No 32 ON SIDE In Portu-
guese: Portuguese . . . Jewish
. . . Fund for Poor

NY/MJS 401

124

**Birthday Presentation
Lithograph**

England, mid 19th century

Façade of the Tomb of the Kings,
Jerusalem

W.H. Bartlett, lithograph E.
Challis

Colored lithograph on paper

H. 6⅛ in. W. 7¼ in.

Inscribed on mat:

In English: To Michael happy
birthday Dec. 7th '86/ As there
are no Kings left let us/ bury all
our worries there/ Yours Teddy
[Kollek]

In Hebrew: mazal tov

NY/MJS 434

125

**Art Moderne
Footed Stove-form**

Estonia, 20th century

Silver; engraved, embossed, cast
handle

H. 5½ in. W. 3 in. D. 2⅝ in.

Marks: Tardy, p.110

In Hebrew: FRONT In aid of
women

In German: BACK Women's
Society

NY/MJS 403

126

Art Nouveau Covered Cup

Estonia, 20th century

Silver; embossed, engraved,
cutout, cast handle

H. 2⅝ in. Diam. 2⅛ in.

In German: For our Talmud
Torah

Marks: Tardy, p. 110

In Hebrew: Gift of gold

NY/MJS 405

127

Souvenir Box

Jerusalem, about 1940

Olivewood; carved, painted

H. 2⅝ in. W. 3¾ in. D. 5⅝ in.

In English and Hebrew: Jerusalem

NY/MJS 409

128

Art Deco Curved Box

Denmark, 20th century

Pewter; cast

H. 4⅛ in. W. 2¾ in. D. 1⅝ in.

In Danish: Society for the Sick

In Hebrew: Happy is the one who
considers the poor. (Psalm 41:2)

NY/MJS 407

129

Canister-form

Germany, inscribed 1898

Warburg family box

Tin, painted red; gold inscription,
brass lock

H. 5 in. Diam. 2⅞ in.

In German: Sarchen Mojes
Warburg/ died 10 October 1884/
. . .ucy W. . .urg/ died 17
November 1898

NY/MJS 408

130

Book-form

Berlin, early 20th century

Maker: John J. Moser

Brass, leather; engraved, cutout,
embossed

H. 4½ in. W. 3 in. D. ⅞ in.

In Hebrew: Land of Israel/ Jewish
National Fund/ ON SPINE You
shall give redemption to the land
(Leviticus 25:24)

NY/MJS 406

131

Book-form

Origin unknown, 20th century

Wood; carved, stained

H. 6⅜ in. W. 4⅛ in. D. 2¾ in.

In Hebrew: ON SPINE Charity for
the Society of Buying Books and
Acts of Kindness [such as granting
loans] BACK The world is
sustained by three things: Torah,
worship, and acts of kindness.
(Pirkei Avot 1:2) FRONT The
person who has acquired Torah
has acquired the life of the world
to come./ Pay heed to the chil-
dren of the poor, for from them
comes Torah. (Pirkei Avot 2:8)

NY/MJS 413

SELECTED BIBLIOGRAPHY

Avigad, Nahman. "A Hebrew Seal Depicting a Sailing Ship," *Bulletin of American Schools of Oriental Research*, 1982.

Barnett, R. D., ed. *Catalogue of the Permanent and Loan Collections of the Jewish Museum, London*. London: Published for the Jewish Museum by Harvey Miller; Greenwich, Conn.: New York Graphic Society, 1974.

Benjamin, Chaya. *The Stieglitz Collection: Masterpieces of Jewish Art*. Jerusalem: Israel Museum, 1987.

Bezalel 1906-1929. Jerusalem: Israel Museum, 1983.

Encyclopaedia Judaica. 16 vols. Jerusalem: Keter Publishing House; New York: Macmillan, 1971-72.

Fine European Silver. Christie's Catalog. Geneva, Wednesday, May 13, 1981.

Friedenberg, Daniel M. "The Evolution and Uses of Jewish Byzantine Stamp Seals." *The Journal of the Walters Art Gallery*, vol. 52, 1993. (forthcoming)

Gans, Mozes Heiman. *Memorbook, History of Dutch Jewry from the Renaissance to 1940*. Baarn, Netherlands: Bosch & Keuning N.V., 1971.

Gates of Prayer. The New Union Prayerbook. Weekdays, Sabbaths, and Festivals. Services and Prayers for Synagogue and Home. New York: Central Conference of American Rabbis, 1975.

Grafman, Rafi. Study of early 1700s Jewish silverwork in related Frankfurt workshops. (Work in progress, to appear 1994).

Grossman, Cissy. *The Jewish Family's Book of Days, with Illustrations from the Judaica Collection of Central Synagogue*. New York: Abbeville Press, 1989.

————. *A Temple Treasury, The Judaica Collection of Congregation Emanu-El of the City of New York*. New York: Hudson Hills Press in Association with Congregation Emanu-El of the City of New York, 1989.

Guralnik, Nehama, with contributions by Eugen Kolb and Jerzy Malinowski. *In the Flower of Youth: Maurycy Gottlieb 1856–1879*. Exhibition catalog. Tel-Aviv: Tel-Aviv Museum, 1991 and National Museum of Warsaw, 1991.

The Holy Scriptures, According to the Masoretic Text. Philadelphia: Jewish Publication Society of America, 1917.

Jüdisches Lexikon, Ein enzyklopädisches Handbuch de jüdischer Wissens in vier Bänden, ed. Dr. Georg Herzlitz and Dr. Bruno Kirschner. vol. 2. Berlin: Judischer Verlag, 1928.

Kayser, Stephen S. and Guido Schoenberger, eds. *Jewish Ceremonial Art*. Catalog of an exhibition held at the Metropolitan Museum of Art, New York, commemorating the American Jewish Tercentenary. [Also published as *Art of the Hebrew Tradition*.] Philadelphia: Jewish Publication Society of America, 1955.

Kirshenblatt-Gimblett, Barbara, and Cissy Grossman. *Fabric of Jewish Life*. Vol. 1, *Textiles from the Jewish Museum Collection*. Exhibition catalog. New York: Jewish Museum, 1977.

Lileyko, Halina. *Srebra warszawskie w zbiorach Muzeum Historycznego m.st.Warszawy* (Warsaw Silver in the Collection of the Warsaw Museum of History and Painting). Warsaw: Panstwowe Wydawnictwo Naukowe, 1979.

Mann, Vivian. "Forging Judaica: The Case of the Italian Majolica Seder Plates," *Art and its Uses Studies in Contemporary Jewry, an Annual*, Vol. 6. New York: Oxford University Press, 1990.

————. *Gardens and Ghettos: The Art of Jewish Life in Italy*. Exhibition catalog. Berkeley: University of California Press, 1989.

Mult es Jovo. Ed. Dr. Jozsef Patai. Budapest: vol. 14, Aug - Sept, 1924.

Narkiss, M. [Mordechai]. *The Hanukkah Lamp*. Jerusalem: Bney Bezalel, 1939.

Pazzi, Piero, ed. *I Punzoni Dell'Argenteria E Oreficeria Veneziana*. Venice: Monastero di San Lazzaro degli Armeni, 1990.

Pickford, Ian, ed. *Jackson's Silver & Gold Marks of England, Scotland & Ireland*. 3rd revised and enlarged edition. Suffolk, England: Antique Collector's Club, 1989.

Rembrandt: Selected Paintings. Introduction by Tancred Borenius. London: The Phaidon Press, 1949.

Rosenberg, Marc. *Der Goldschmiede Merkzeichen*. 3d ed., enl. and ill. 4 vols. Frankfurt: Frankfurter Verlags-Anstalt, 1922-28.

Roth, Cecil. "The Lord Mayors' Salvers." *Connoisseur*, September, 1933.

Sabar, Shalom. *Ketubbah: Jewish Marriage Contracts of the Hebrew Union College Skirball Museum and Klau Library*. Philadelphia: The Jewish Publication Society of America, 1990.

Scheffler, Wolfgang. *Goldschmiede Hessens: Daten, Werke, Zeichen*. Berlin/New York: De Gruyter, 1976.

Schoenberger, Guido. "A Silver Sabbath Lamp from Frankfort-on-the-Main." In *Essays in Honor of Georg Swarzenski*, edited by Chaim Stern, pp.189-97. Chicago: Henry Regnery, 1951.

Schoenberger, Guido and Tom L. Freudenheim. *The Silver and Judaica Collection of Mr. and Mrs. Michael M. Zagayski*. Exhibition catalog. New York: Jewish Museum, 1963.

Schrire, T. *Hebrew Amulets: Their Decipherment and Interpretation*. London: Rutledge & Kegan Paul, 1966.

Shachar, Isaiah. *Jewish Tradition in Art: The Feuchtwanger Collection of Judaica*. Translated by R. Grafman. Jerusalem: Israel Museum, 1971, 1981.

Tardy International Hallmarks on Silver. Paris: Tardy, 1981.

The Union Haggadah. Home Service for the Passover. Cincinnati: Central Conference of American Rabbis, 1923.

The Union Prayerbook for Jewish Worship. Newly Revised Edition. Edited by the Central Conference of American Rabbis. 2 vols. Cincinnati: Central Conference of American Rabbis, 1940, 1945.

Voet, Elias, Jr. *Merken van Amsterdamsche Goud-en Zilversmeden*. The Hague: M. Nijhoff, 1912.

Wooley, C. L. "Royal Cemetery." *Ur Excavations*, vol.II, 1934.

Founded in 1875, Hebrew Union College–Jewish Institute of Religion is the nation's oldest institution of higher Jewish education and the academic and professional leadership development center of Reform Judaism. HUC-JIR educates men and women for service to American and world Jewry as rabbis, cantors, educators and communal workers and offers graduate and postgraduate degree programs for scholars of all faiths. With campuses in New York, Cincinnati, Los Angeles and Jerusalem, HUC-JIR's scholarly resources comprise renowned library, archives and museum collections, biblical archaeology excavations and academic publications.